ArtSaves

STORIES, INSPIRATION AND PROMPTS SHARING THE POWER OF ART

Jenny Doh

NORTH LIGHT BOOKS

Cincinnati, Ohio
www.createmixedmedia.com

www.fwmedia.com

15 14 13 12 11 5 4 3 2 1

DISTRIBUTED IN CANADA BY FRASER DIRECT

100 Armstrong Avenue

Georgetown, ON, Canada L7G 5S4

Tel: (905) 877-4411

DISTRIBUTED IN THE U.K. AND EUROPE BY F&W MEDIA INTERNATIONAL

Brunel House, Newton Abbot, Devon, TQ12 4PU, England

Tel: (+44) 1626 323200, Fax: (+44) 1626 323319

Email: enquiries@fwmedia.com

DISTRIBUTED IN AUSTRALIA BY CAPRICORN LINK

P.O. Box 704, S. Windsor NSW, 2756 Australia

Tel: (02) 4577-3555

Art Saves: Stories, Inspiration and Prompts Sharing the Power of Art by Jenny Doh.

ISBN-13: 978-1-4403-0906-9

ISBN-10: 1-4403-0906-X

EDITORS: Jenny Doh and Sarah Meehan

DESIGNER: Julie Tietsort

PRODUCTION COORDINATOR: Greg Nock

PHOTOGRAPHER: Cynthia Shaffer

METRIC CONVERSION CHART

TO CONVERT	TO	MULTIPLY BY
Inches	Centimeters	2.54
Centimeters	Inches	0.40
Feet	Centimeters	30.50
Centimeters	Feet	0.03
Yards	Meters	0.90
Meters	Yards	1.10

DEDICATION

I dedicate this book to all of my former and future teachers of art and music. I thank them for demonstrating that even when we feel totally lost, we can find our way back through the creative process.

ACKNOWLEDGMENTS

Tonia Davenport listened to the concept for *Art Saves* and understood it deeply and immediately. Vanessa Lyman's valuable feedback helped strengthen the overall narrative of the entire book. Ronson Slagle's design-related support made the production of this work a strong and cohesive process. Tonia, Vanessa, Ronson, and the entire team at F+W Media and North Light Books: I am indebted for all of your support. Thank you.

Sarah Meehan, Julie Tietsort, Cynthia Shaffer, Gerardo Mouet, Monica Mouet, and Andrew Mouet were the ones closest to me throughout this project and I am grateful for their talent, time, dedication, and love. Thank you.

ABOUT THE AUTHOR

Jenny Doh is president and founder of *www.crescendoh.com*, an online community that features stories about the power of art. Jenny is former Editor-in-Chief of *Somerset Studio* and its many sister publications. Prior to publishing, she worked as a social worker in the field of public child welfare. Aside from work, Jenny values spending time and sharing lots of laughter with her husband, daughter, and son, in the city that they love most: Santa Ana, California.

Table of Contents

to show my SOUL that I am listening

create what you

seek but can not

FIND

Introduction

I'll never forget my grandmother teaching me how to knit as a young girl. She was truly a master knitter who could conceptualize a pattern in her head, and in almost no time create a beautiful knitted garment.

As she was teaching me *how* to knit, I remember one day asking her *why* she knit. It was a moment when I thought I had asked her to explain to me the secret to life. Her response was given with a knowing smile as she explained that the process of knitting made her happy. The act of knitting (as opposed to the final knitted object) brought her happiness. What a concept.

This simple truth that my grandmother explained to me years ago is something that the contributing artists who have convened for this book, *Art Saves*, profoundly understand. Each of the contributors are master creators in their respective fields…from mixed-media, altered art, photography, art quilting, art jewelry, crochet, lettering arts, and digital arts. They are: **Kelly Rae Roberts, Lynn Whipple, Susannah Conway, Robert Dancik, Karen Michel, Rebecca Sower, Michael deMeng, Sarah Hodsdon, Suzi Blu, Stephanie Lee, Susanna Gordon, Marie French, Susan Tuttle, Lisa Engelbrecht, Jette Clover, Melody Ross, Christine Mason Miller, LK Ludwig, Drew Emborsky**, and yours truly.

As you read through this book, you will find that many of the artists offer the *how*, in terms of the stellar projects that they teach through the presentation of beautiful photographs and well-written instructions. More importantly, what all of the artists offer is to go beyond the how and explain the unique circumstances that they have experienced, in order to get to the universal *why*…which is that through the creative process, we not only find happiness, but also we find meaning, hope, and a way to connect to ourselves and to others.

The contributors also offer compelling "Pay it Forward" ideas. These thoughts are written in each artist's words, and they challenge us to think beyond ourselves, nudging us to widen the circle of creativity and invite others to experience and understand the significance of the creative process and how indeed, art saves.

Jenny Doh

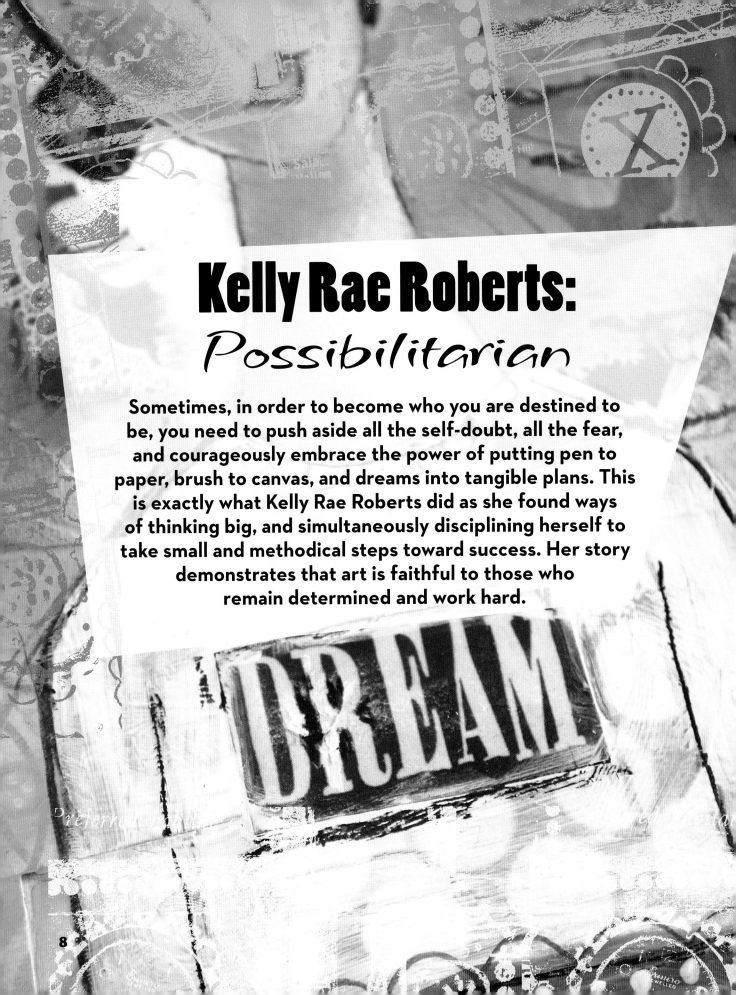

Kelly Rae Roberts:
Possibilitarian

Sometimes, in order to become who you are destined to be, you need to push aside all the self-doubt, all the fear, and courageously embrace the power of putting pen to paper, brush to canvas, and dreams into tangible plans. This is exactly what Kelly Rae Roberts did as she found ways of thinking big, and simultaneously disciplining herself to take small and methodical steps toward success. Her story demonstrates that art is faithful to those who remain determined and work hard.

INSPIRED LESSONS

Professional training is not a prerequisite for being an artist. Even without formal art school training, Kelly Rae has learned that art makes room for all, whether schooled or not. The most important thing is to just begin.

It's the process, not the destination. If you let them, the pressures associated with being an author, teacher, and artist can take their toll. That's why Kelly Rae insists on honoring the now.

Prove it. Successfully tackling an activity outside the creative zone can boost self-confidence. For Kelly Rae, it was running. It was an unexpected activity that she dared herself to take on. By proving that she could do it, she found that the exhilaration from running could aid her self-confidence to make important artistic breakthroughs.

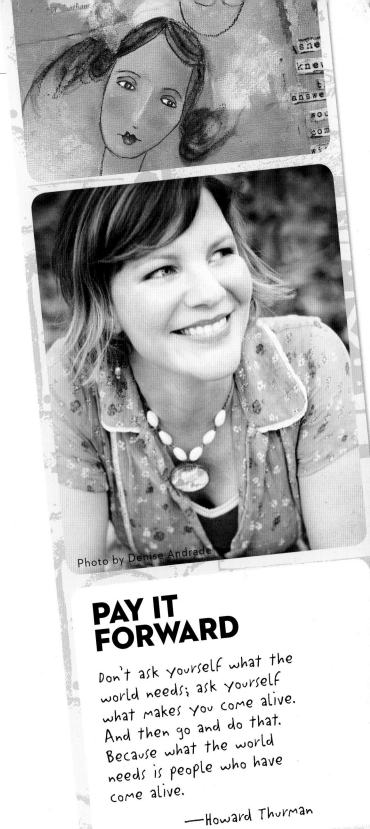

Photo by Denise Andrade

PAY IT FORWARD

Don't ask yourself what the world needs; ask yourself what makes you come alive. And then go and do that. Because what the world needs is people who have come alive.

—Howard Thurman

believe in possibilit

SEEING THE POSSIBILITIES

Her bright and colorful, collage-inspired artwork has become synonymous with themes of love and positivity, and has gained Kelly Rae a devoted fan following. In order to claim these artistic successes as hers, Kelly Rae had to first recognize herself as an artist. "I think for me, I considered myself a successful artist once I was able to accept and say out loud 'I am an artist,'" she says. "It meant owning what I had to own, and being brave enough to see the expansion of my life's possibilities."

Kelly Rae delights in being able to help others become their own "possibilitarians" through her role as an art instructor. It is an experience that she considers to be among her most rewarding. "I love watching the blossoming and transformation that happens when students arrive at a workshop all shy and nervous, only to find their rhythm and confidence by the workshop's end," she says. "I can see the joy exploding, their hearts expanding, and their enthusiasm about to burst with all they're discovering." She relishes the honor of providing guidance and support to others as they travel toward their artistic epiphanies.

Creating in the studio is what Kelly Rae loves most, as she makes a mess with paint, stamps, and paper scraps to create meaningful, one-of-a-kind creations. "Art heals the creator during the process of making it," says Kelly Rae. "It goes out into the world to hopefully provide a moment (big or small) of healing, happiness, or joy for someone else when they encounter your work." By sharing her talents with the world, she intends to inspire others to be "possibilitarians" who actively work to actualize the experiences that they need most in their lives.

WHEN THE GOING GETS TOUGH

SAYS KELLY RAE ROBERTS: "WHEN THE GOING GETS TOUGH, THE TOUGH NEED TO REST, NURTURE, BE SURROUNDED BY GOOD PEOPLE, AND KNOW THAT EVEN IN SADNESS AND STRUGGLE, THERE IS BEAUTY."

Having spent most of her life surrounded by strong, capable women, it's no surprise that much of Kelly Rae's artwork includes depictions of female figures, often paired with words or phrases that encourage positivity.

IN KELLY RAE'S OWN WORDS:
BLESSINGS ON BILLBOARDS

I love finding kind messages in unexpected places. Whether it's a message scribed on the sidewalk, or a hand-written note left behind on a mirror for a stranger to find, I think the world needs more moments of kindness that make us pause to consider all that we have in the midst of our busy days. Recently, I was in New York City and I spotted an old, abandoned billboard upon which someone had spray-painted the words "bless yourself." As I passed by the sign in my taxi, hurrying to my next appointment, reading those words quickly re-centered me, and reminded me of what's important in life.

UNEXPECTED AFFIRMATIONS

Guerilla acts of kindness, such as leaving simple affirmations in public places for a passersby to discover, are easy and rewarding ways to have a positive impact on the lives of others. If you have a pen, a scrap of paper, and a few compassionate words, then you can make someone's day with a surprise affirmation.

IN PUBLIC PLACES

Jot down several messages of hope on slips of paper and leave them in public places. For example, you can write a message that reads "you are gorgeous just the way you are" onto a sticky note and place it on the mirror of a public restroom. You can do this inside of restaurants, post offices, grocery stores, on counters, on bike racks, or practically anywhere.

Photo by Tracey Clark

Photo by Alessandra Cave

Affirmations, both in her life and in her art, keep Kelly Rae focused on the things that she holds closest to her heart, and help her to combat occasional feelings of self-doubt.

CREATIVE JOURNEY

The main reason Kelly Rae held herself back from entering the art world until she was 30 years old is because she was sure she wasn't an artist. "Why was I sure?" she asks. "Because I hadn't gone to art school, and you have to go to art school to be an 'artist,' right?" Even though she didn't believe that she was cut out to be an artist, Kelly Rae knew that her life felt incomplete without her creative voice. "Now I know what I was missing all of those years that I wasn't making art," she says. "I was missing that joy that permeates your whole life when you find and then lean into your passion."

BADGES OF THE HEART

Just like the badge of "artist," the badge of "runner" was one that Kelly Rae had never claimed for herself. Interestingly, when she and her husband moved to Portland, Oregon, the scenic surroundings inspired her to get her running shoes on and just go for it. She wasn't a runner by nature but her drive to excel was there from the start. "Training day-in and day-out was difficult, and there were definitely moments when I wanted to give up," she says, "but I felt that if I could make it through those moments and find the strength to persevere, I could take on the world."

By taking a stance against her inner critic, Kelly Rae has been able to not only nurture her passion and launch a successful career in the arts, but also to give the gift of inspiration to so many others. Says Kelly Rae: "Brave in sadness, brave in love—that's what I hope to leave as my mark."

AT HOME

Hide notes in the dresser drawers of your children so that they find sweet sentiments from you the next time they reach in to grab a shirt or a pair of socks. You can also do the same thing at a friend's house. You may not have access to their closets, but you'll probably be able to sneak a message into one of their kitchen drawers or cabinets.

WITH YOUR KIDS

Using sidewalk chalk, write messages of kindness and hope on the sidewalks in your neighborhood (or any sidewalks in town). This is a great exercise to do with the young people in your life.

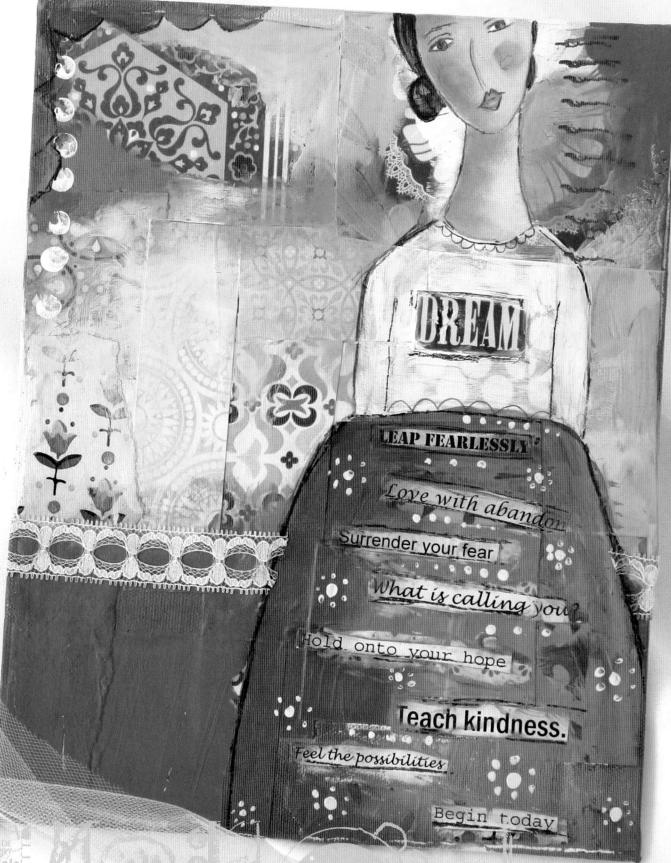

14

AFFIRMATIONS COLLAGE

Kelly Rae believes that inside each person's heart there exists a collection of affirmations—small whispers nudging them to dream bigger, take risks, and trust their creative spirit. Developing a list of personal affirmations to use in artwork not only allows the artist to identify what they want more of in their life, but also to make deeply meaningful art that reminds them to be their truest self. This collage project is one that teaches us how to incorporate layers of papers and paints, along with a bit of charcoal pencil work, with affirming messages of hope.

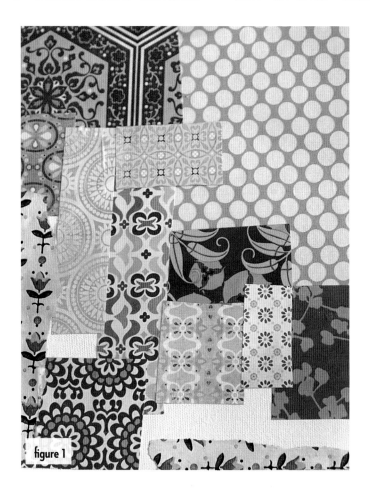

figure 1

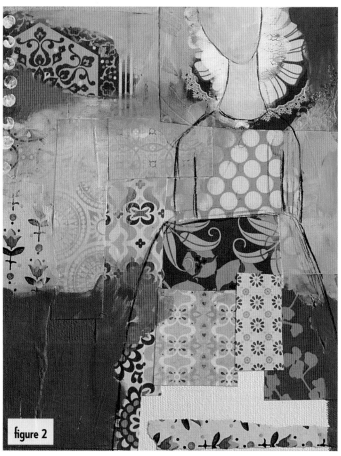

figure 2

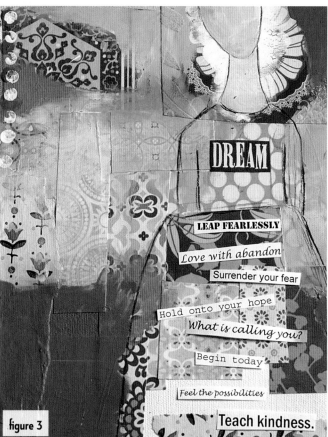

DREAM

LEAP FEARLESSLY

Love with abandon

Surrender your fear

Hold onto your hope

What is calling you?

Begin today

Feel the possibilities

Teach kindness.

figure 3

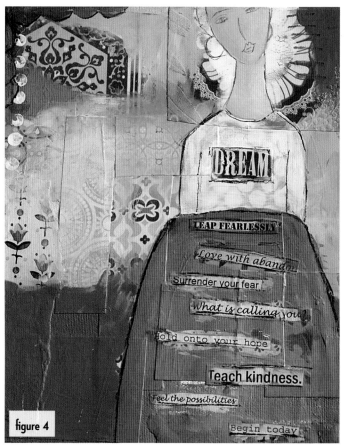

DREAM

LEAP FEARLESSLY

Love with abandon

Surrender your fear

What is calling you

Hold onto your hope

Teach kindness.

Feel the possibilities

Begin today

figure 4

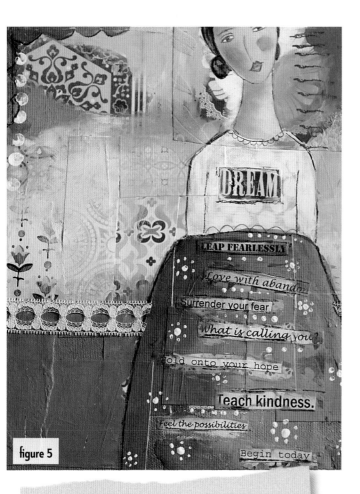

figure 5

MATERIALS:

- base surface, such as a canvas, matboard, heavy watercolor paper, or wood panel, 8" x 10" (20cm x 25cm)
- collage papers (and assorted embellishments)
- regular gel medium in gloss (Golden)
- charcoal pencil
- paper towels
- sharp kraft knife
- cotton swabs
- paintbrushes
- fluid acrylic paint (Golden)
- computer-generated affirmations
- white gesso
- archival varnish spray in gloss (Golden)

INSTRUCTIONS:

1. Cut assorted collage papers into rectangular shapes of various sizes. Randomly affix them onto the base surface using gel medium, covering the entire area (figure 1).

2. After collaging the surface, paint a coat of gel medium over the entire collage. This will help seal the papers and will allow for rubbing excess paint off in later steps. Allow to dry.

3. Using a charcoal pencil, sketch the outline of a figure onto the collaged surface. Those who are uncomfortable with drawing a figure or a face may want to try drawing other shapes like hearts, flowers, or birds. Don't draw the details yet, as they will come in a later step (figure 2).

4. Randomly add paint to the collaged background, leaving the inside of the outlined figure bare. While the paint is still wet, use a dampened paper towel to wipe away portions of the paint to expose the collage papers underneath. Repeat this process until the desired effect is achieved.

5. Type out a list of personal affirmations in a word processing program, selecting different font faces and sizes for each statement.

6. Print out the affirmations, and cut them out using a sharp kraft knife. Arrange them inside the sketched figure and secure with gel medium. Coat each affirmation with a layer of gel medium to allow for paint to be rubbed off in a later step. Tip: Those without a printer can write their affirmations out using a pen and paper (figure 3).

7. Paint the top of the figure's dress, using a dampened cotton swab to remove excess paint that covers the affirmations. Repeat as necessary (figure 4).

8. Fill in the face with gesso. Once dry, draw facial features with a pencil and then paint in the skin and other accents.

9. Finish painting the other elements of the piece (such as the hair and wings). Outline the image using black paint or a charcoal pencil. Embellish with lace and other ephemera as desired (figure 5).

10. After the painting has dried, spray it with varnish to seal.

Lynn Whipple:
Intuitive

If you take yourself too seriously, you might miss all the fun. For many artists including Lynn, fun is a critical part of the artistic life, which is why she has always approached her art and life with a whole lot of fun and plenty of zeal. This playful outlook on life is one that has carried Lynn from crayons to collage, all the way from childhood into her adult life. As much as Lynn delights in the frolicsome facet of art, she has come to understand its deep healing powers by witnessing firsthand how it saved a loved one, who through art, overcame the grips of depression and grief.

INSPIRED LESSONS

Create something. If you want to contribute something worthwhile, create something with your hands. Even if you don't know what will happen to the creation once it is made, it is the actual making of art that is the greatest gift we can give ourselves and the world. This is a lesson that Lynn sees play out in everyday in life—from baking a cake, to drawing a happy face...for Lynn, it all counts. It's all important.

Play. There's a time when you need to turn down all distractions and work hard. But for Lynn, just as important as working hard is giving oneself permission to play. Even if it's a short 20 minutes in the middle of the day, Lynn has learned that it is through play that we discover new ideas and new approaches to all that we do.

Have empathy. Be aware of those around you and try to feel what it would be like to walk in their shoes. Developing your empathic skills makes you in tune not only with others, but yourself. Lynn learned the power of empathy as she stood by a family member's battle with depression.

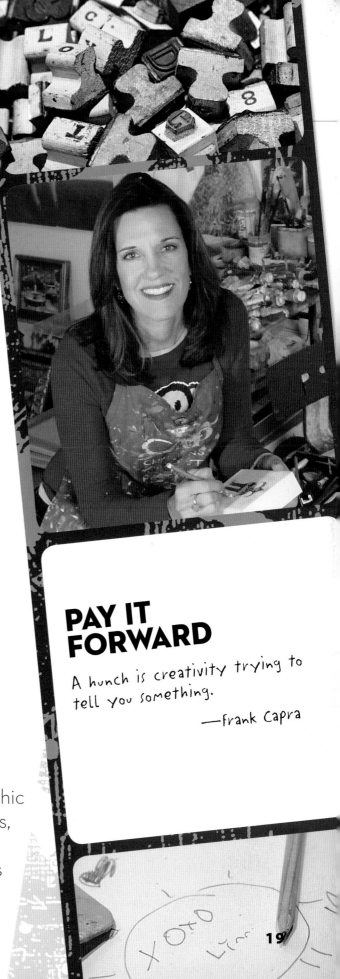

PAY IT FORWARD

A hunch is creativity trying to tell you something.

—Frank Capra

19

IN LYNN'S OWN WORDS:
GIVE PERMISSION

It's important to give yourself permission. Permission to make things, and permission to play. Permission to carve out time for nourishing activities big and small will allow you to fill yourself up in a way that you can send out more love and encouragement to all those you come in contact with.

GIVE GIFTS

My all-time favorite way to start the day is to craft a simple, handmade card or note to send to someone special. This is a great way to get your hands moving—just give yourself the room to play and trust

WHEN THE GOING GETS TOUGH
SAYS LYNN WHIPPLE: "WHEN THE GOING GETS TOUGH, THE TOUGH EAT CHOCOLATE."

A LITTLE LOVELY

Lynn believes that making art is all about giving. "You are giving to yourself when you create, which is intrinsically healing," she says. "Then your efforts go out into the world and evoke things in the people who come in contact with your work. Shared creativity, shared inspiration—shared healing perhaps." Lynn's art—which playfully melds elements of collage, drawing, altered photography, and painting with her signature touches of humor and quirkiness—is a testament to her pursuit to put "a little lovely" out into the world.

The impact that "a little lovely" can have in the world, in Lynn's perspective, is monumental. "When we are faced with something stressful or with a loss, making art is the one thing that makes you feel whole again," she says. "You can process emotions, tell stories, release anything that comes up."

ART SAVES

Emotions needing creative release reached their peak when Lynn's beloved father-in-law, George, passed away. It was a devastating loss especially for Marty, his wife of more than 35 years who had been a passionate and thriving artist throughout her life. After George's passing, Marty not only lost interest in making art, she struggled to find strength to continue on without him. "Her grief was unbearable and as the weeks unfolded, the one thing that gave her any hope at all was starting a journal and writing in it daily," says Lynn. Over time, Marty began to reclaim her drive to create, exploring oil painting full-time, creating collages, producing jewelry to show in galleries, and even teaching a class on making art from family memories.

Watching Marty transform from a wilting flower to a vibrant blossom has given Lynn newfound appreciation for the power of art. Says Lynn: "She has worked her way through the toughest time in her life by making art, and now she is sharing that gift with others. She is blooming brilliantly, healed and rejuvenated by dipping back into her own creative well."

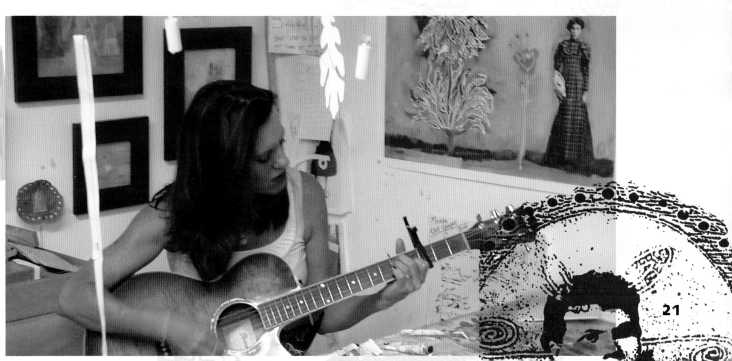

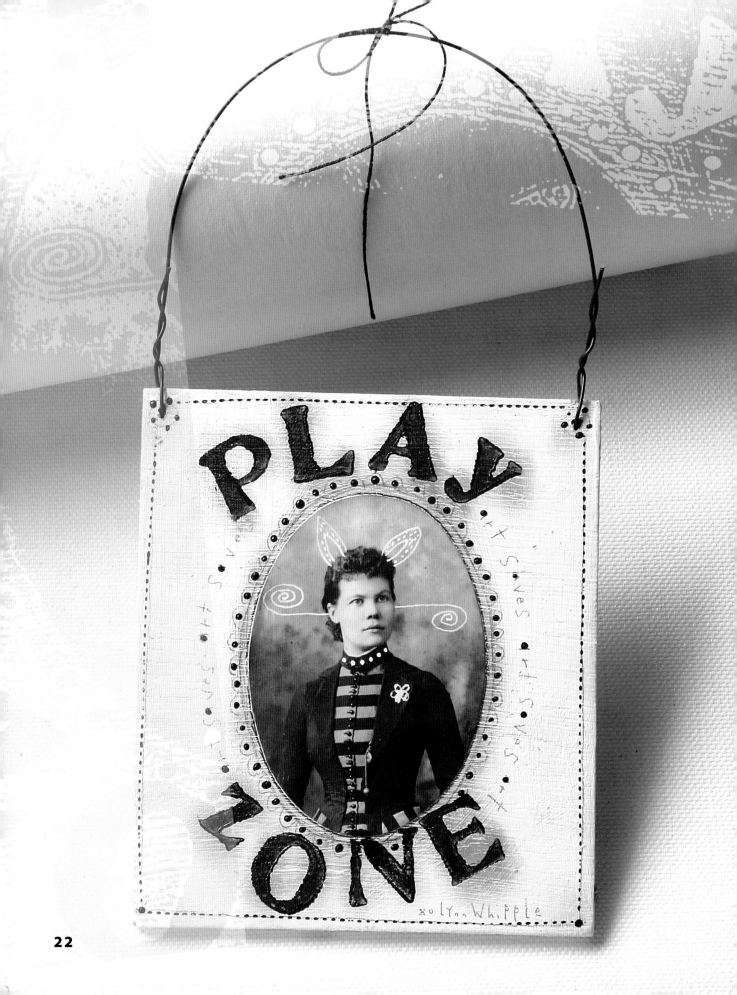

PERMISSION PLAQUE

This project contains a message that is all about giving ourselves and one another permission to work and play. It is a two-sided plaque featuring vintage portraits with a touch of whimsy that is designed to be hung on the door; it beautifully announces to all whether you are at play or at work. With a wood panel, paint, rubber stamps, and vintage photographs, Lynn teaches how to create a little lovely Permission Plaque.

MATERIALS:

- wood panel (or a book cover)
- drill
- sandpaper
- color copies of vintage photos on heavyweight paper
- adhesive
- letter stamps and black inkpad
- artist's acrylic paints
- craft wire
- wire cutters
- pencil
- white gel pen

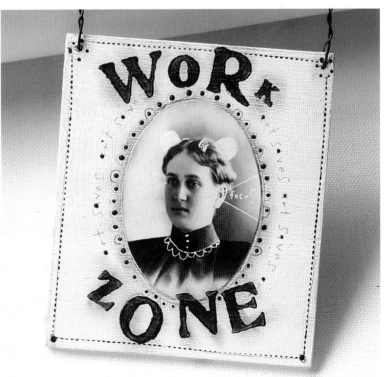

INSTRUCTIONS:

1. At most home improvement stores in the lumber department, you can request to have sheets of plywood cut into desired measurements. This plywood panel was cut to measure 5" x 6" (13cm x 15cm). Once cut, use a hand drill to create holes at the top two corners. Use sandpaper to smooth out any rough spots and wipe clean. Apply a coat of light-colored acrylic paint onto both sides of the wood panel (figure 1). (NOTE: An alternative to plywood is to use a book cover from an old hardback book, and to create the holes by using an awl.)

2. Make copies of vintage photos and use a pencil to draw a desired shape onto the copies and cut them out—one for either side (figure 2).

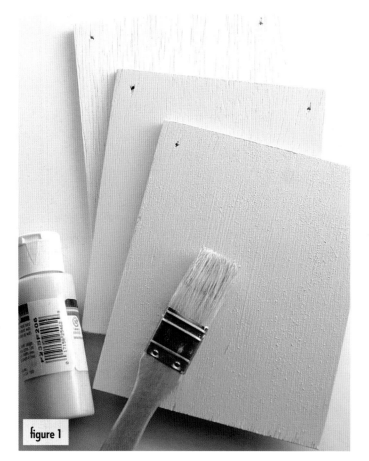

figure 1

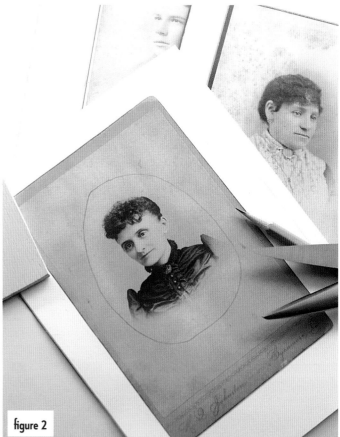

figure 2

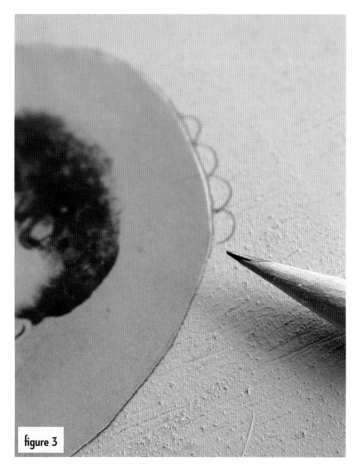

figure 3

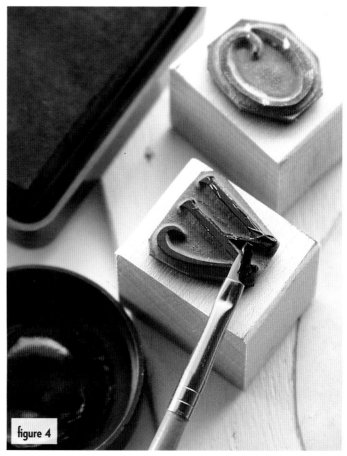

figure 4

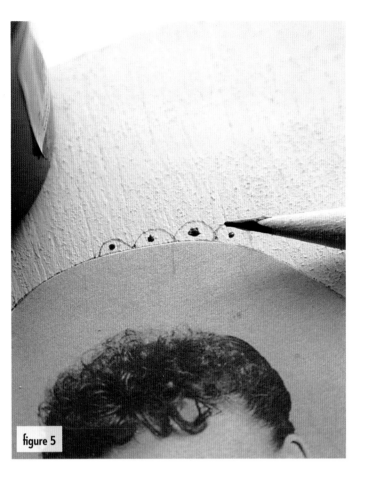

figure 5

figure 6

figure 7

3. Adhere cut out photos to the panel on either side. Use a pencil to add scallops and additional related text to the panel. Use your fingers to slightly blend and smudge the pencil work (figure 3).

4. Add words by using letter stamps by first inking the stamps with a black inkpad and then adding acrylic paint to the stamp before making the impression. This will allow the letters to have a nice dark edging to them (figure 4).

5. Use the tip of a sharpened pencil to add dots of acrylic paint (figure 5).

6. Use a white gel pen to add flourishes and decorations (figure 6).

7. Use wire cutters to cut a length of craft wire and anchor both ends into the holes at the top of the wooden pieces by threading the wire through and then twisting in place (figure 7).

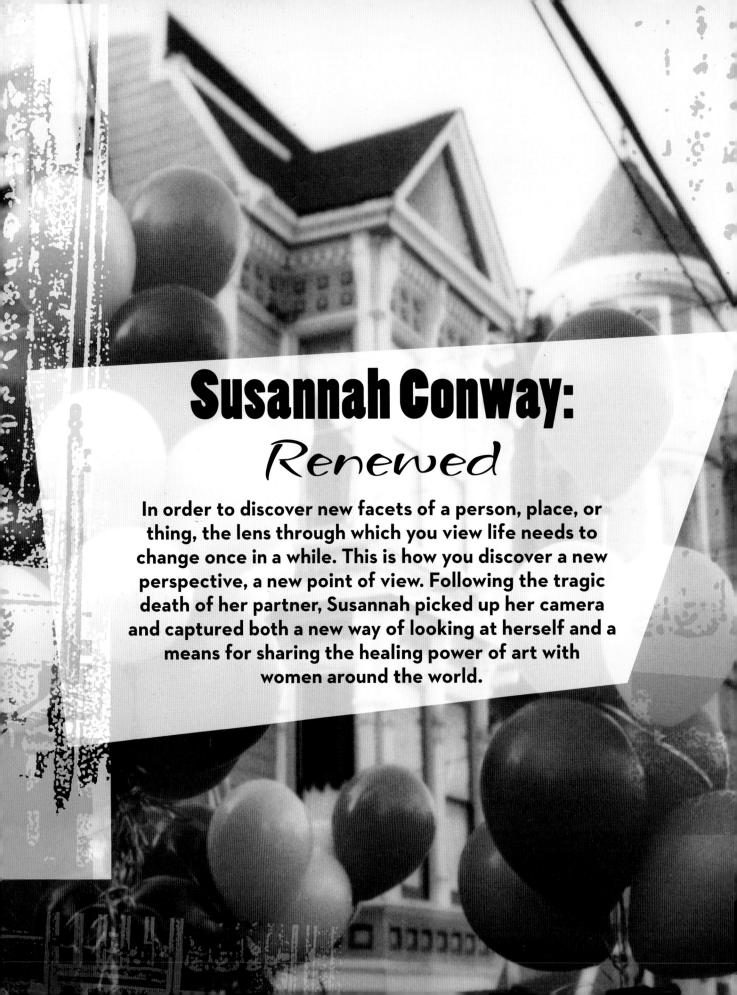

Susannah Conway:
Renewed

In order to discover new facets of a person, place, or thing, the lens through which you view life needs to change once in a while. This is how you discover a new perspective, a new point of view. Following the tragic death of her partner, Susannah picked up her camera and captured both a new way of looking at herself and a means for sharing the healing power of art with women around the world.

INSPIRED LESSONS

Find a community. Regardless of how much talent you have and how well-stocked your studio is, creativity comes alive through connecting with other like-minded people. Susannah learned this lesson after her partner's untimely death, as she struggled to find a way out of her deep sadness. As she reached out and engaged and spent time with other creatives she met through blogging, a renewed sense to create finally became hers.

Connect with nature. When the hustle and bustle of life gets too intense, there's nothing like a dose of mother nature to get you centered. This is a lesson that Susannah discovers every day, as she takes long walks to breathe in fresh air and new perspective.

Say it all. The measure of good art is the artist's ability to broach both the highs and lows found in life. Susannah has learned that new depths to her art are found only when she dares to let herself address all of the emotions that she experiences...both happy and sad.

PAY IT FORWARD

It is part of the photographer's job to see more intensely than most people do. He must have and keep in him something of the receptiveness of the child who looks at the world for the first time or of the traveler who enters a strange country.

—Bill Brandt

VISION & VOICE

Though she had a deep connection with the arts from a young age, Susannah didn't truly discover how powerful this connection could be until a sudden heart attack claimed the life of her partner a few years ago. Thirteen months into her bereavement, Susannah discovered the world of blogging—a world that introduced her to a new community and a new creative breakthrough that gave her a renewed strength to continue with her art. "Finding a creative community encouraged me to pick up a camera again and bring my words and images together…creating a blog gave me something to do each day and a way to reach out to the world outside my home," she says.

Eventually, Susannah traveled to the United States to spend time with her new friends—a trip that was pivotal in making her realize that she was ready to continue exploring photography. "By reconnecting to my creative side, I found a way to give my world meaning when I'd thought I'd lost everything."

IN SUSANNAH'S OWN WORDS:
TELL THEM WHY

We don't mean to take our loved ones for granted but with our busy lives it's so easily done. Find a photograph of you with someone you care about, slip it inside a card, and tell them how much they mean to you—recount the special memories you share and let them know what's in your heart.

LAYER BY LAYER

The great thing about photography is that it can jump-start a new way of seeing things, and it can also document the evolution and self-awareness of a person. With this in mind, Susannah embarked on a series of self-portraits to illustrate "a changed woman who was re-growing her skin, layer by layer," which would eventually become the foundation of the very first class that she would teach a classroom of women, titled Unravelling: Ways of Seeing My Self. "By the end of the six weeks, I'd seen so many breakthroughs I knew the course was ready to be shared with more women," says Susannah. Now a popular online class and a successful new book, Unravelled has impacted the lives of women around the world and has allowed Susannah to share the lessons she learned during her own grieving process.

"Photography is like a form of medication for me," says Susannah. "Without fail, photography takes me out of myself and shifts my mood. If I'm having a bad day I pack my camera in my bag and go out looking for a new perspective." With her camera bag in tow, a fresh outlook is never more than a few shutter clicks away, giving her the ability to weather life's difficulties and celebrate life's joys.

HELP OTHERS DISCOVER

Spend the day with a few of the children in your life and encourage them to explore their own photographic vision by hosting a photo safari. Provide each child with a disposable camera, choose a theme, and start snapping away. Find ways to help them think outside the box—point out patterns in flowers or unusual color pairings.

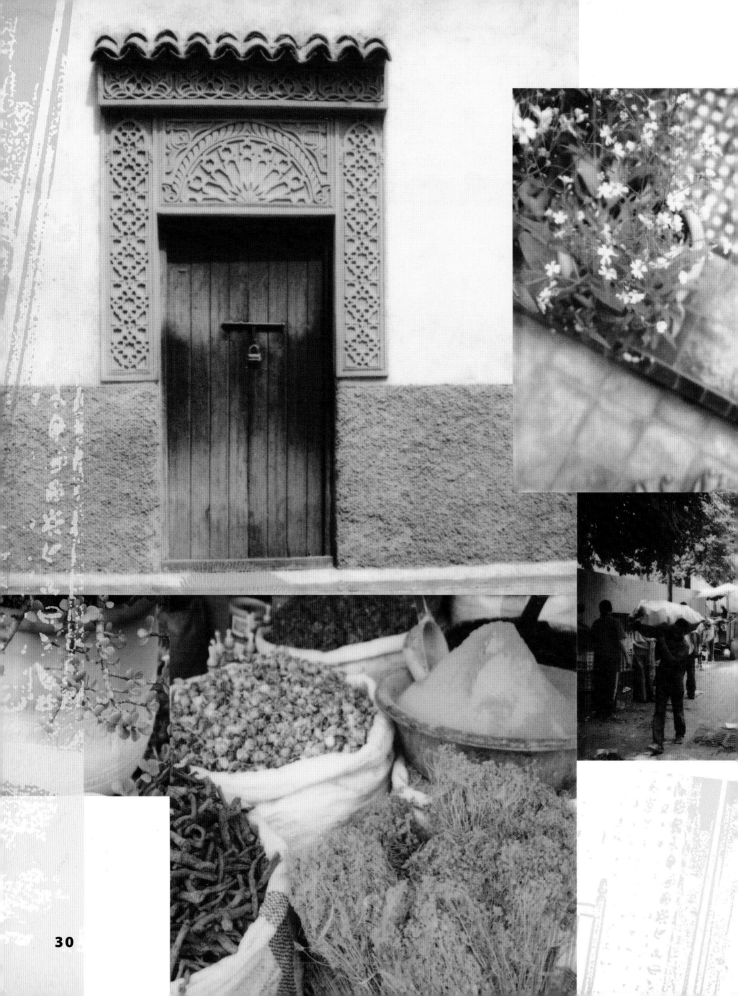

POLAROIDS FROM MARRAKESH

On a recent trip to Morocco, Susannah was dazzled by all the colors, patterns, and vistas. The expression "visual feast" seemed uniquely coined for Marrakesh. As she wandered through the city, she looked for images that captured her own personal experiences of the city. Below are some of the tips that Susannah offers for those interested in using photography to uncover the soul of new places. With the Polaroids, Susannah scanned and created a digital montage that would serve as a rich visual narrative of her experience.

PHOTOGRAPHY TIPS:

- Look for evocative details. "I adored the decorative details found in every nook and cranny of the city—from doorways and rugs to the brickwork, fabrics, and even the floors."

- Look for color themes. "Yellows and browns reflected the heat and spices, while the watery blues felt cooling and calm in comparison."

- Avoid the obvious. "I took photos in the souks but they were filled with tourists. As soon as I turned down a side road, I found the Marrakesh I'd always imagined."

- Group images together. "As I scanned my Polaroids, I intuitively began putting images together through Photoshop to tell a story about the city that I had experienced." (TIP: A good alternative for creating a digital photo montage is to actually make color copies and create a collage montage on a canvas board or other substrate of your choice.)

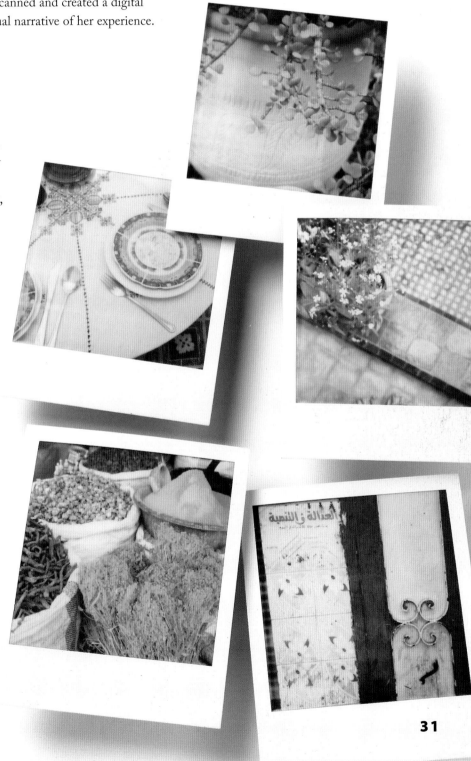

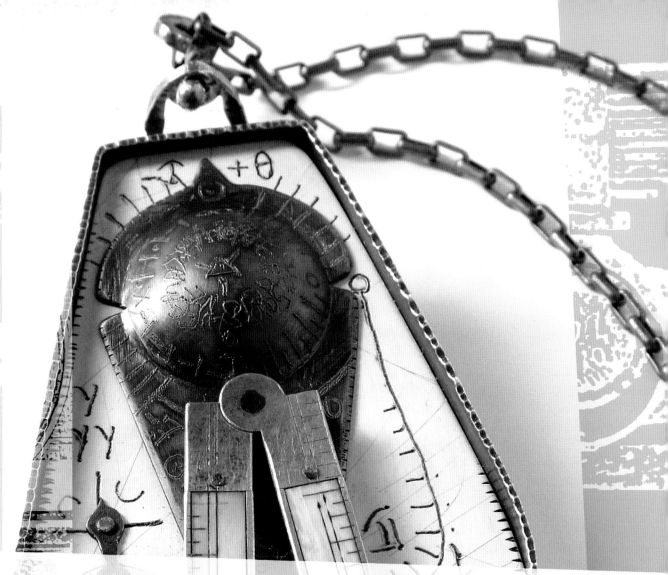

Robert Dancik:
Navigator

In order to move from point A to point B, it's important to invest quality time in surveying the environment. Robert learned this truth early on, as his love of boats and the water intersected with his affinity and skill for the map-making process. Surveying the environment, which precedes the creation of all maps, has parallels to the open-ended exploration involved with play—a non-evaluative process that has fueled Robert's artistic process in his efforts to create, connect, and listen.

INSPIRED LESSONS

Study other cultures. To broaden understanding of others as well as yourself, it's important to look beyond your own backyard. Robert's most profound discoveries about the significance of his art and his life, occurred when he started studying the art and culture of the Maasai—a semi-nomadic people located in Kenya and northern Tanzania.

Imagine and invent. Stories and people can be composed and invented through art. By inventing narratives and characters, Robert has learned that personal matters can be assigned to these "others," thus allowing him an ability to objectify and evaluate those matters from a distance that heightens insight and strengthens clarity.

Embrace the process, reject the evaluation. In order to truly express your art, you need to permit yourself to create without the worry of being evaluated. This is a lesson Robert has learned through his interaction with children, who he regards as the masters of play.

Photo by Douglas Foulke Phtoto Studio

PAY IT FORWARD

Humanity has advanced, when it has advanced, not because it has been sober, responsible, and cautious, but because it has been playful, rebellious, and immature.

—Tom Robbins

OPEN-ENDED EXPLORATION

It wasn't until he was 21 years old, when he took a job as an elementary art teacher (and part-time kindergarten teacher), that Robert Dancik had any interaction with children. "That was my first exposure to kids," explains Robert. "It floored me. I so admired their honesty and brutality…their willingness to go without thought and their ability to play without evaluating." For 15 years, Robert taught kindergarten and the kindergartners taught him, as he learned profoundly the importance of playing, exploring, and being.

For Robert, play is about open-ended exploration, where the final product becomes the byproduct of the process. As an art instructor, Robert observes that most people have a tough time with this concept, as they worry about tending to the potential imperfections of the finished product rather than really and truly allowing themselves to learn and glean information about the journey. And as much as he enjoys teaching the technical aspects involved with his much-revered jewelry-making, Robert encourages his students to refrain from evaluating one's art, but rather soak in the experience of creating.

IN ROBERT'S OWN WORDS:
GET SERIOUS ABOUT PLAY

Do not underestimate the importance of play. Play is serious work. When I play, it is open-ended exploration into my artwork and my processes. I don't focus on where it may lead or what the end product will be, but instead put my attention into enjoying and learning from the experience of simply exploring. So the next time you are creating, don't worry about where you'll end up…just enjoy the ride.

NAVIGATIONAL AIDS

Perhaps Robert's fascination about the process is rooted in his lifelong love of maps. As a child, he grew up on boats and learned to look at nautical maps and developed an appreciation of the mathematical aspects involved with navigation. In college, Robert got a job as a land surveyor and upon finding out that he was an art major, the company asked him to start drawing maps. "Navigational aids are expressly about life," says Robert. "Aren't we all travelers? If so, don't we all need maps? Maps by their nature are layers upon layers of information."

It is in this spirit that Robert has created a large body of work, which is part of his navigational series. Many of his works incorporate the use of Faux Bone, a material that he carves, drills, stamps, and rivets to other metal components to yield one-of-a-kind works that aesthetically invoke imagery of maps, navigational aids, and marks and symbols unique to Robert. It is a body of work that invites viewers to recognize the importance of surveying the land, gleaning information, and enjoying the process.

CREATE AN EMOTIONAL ALPHABET

By creating an "emotional alphabet," I mean developing your own personal set of basic marks and symbols that correlate to the various emotions you feel on a regular basis. Try doodling along with television shows. Create marks inspired by films, music, or art pieces, and then find ways to incorporate the resulting shapes into your art.

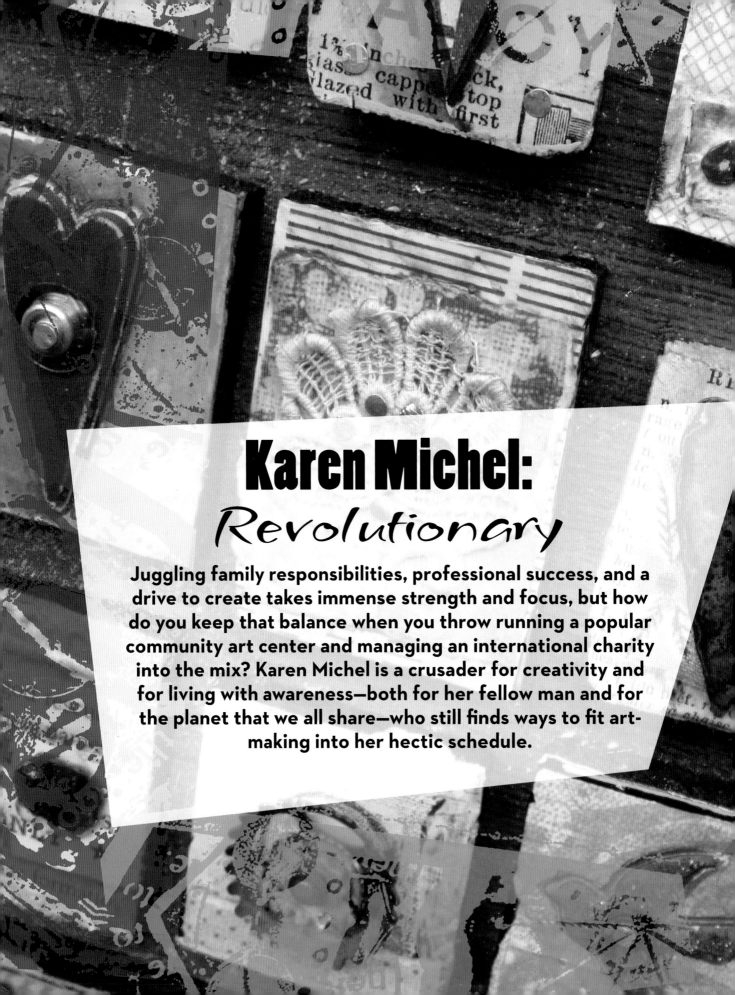

Karen Michel:
Revolutionary

Juggling family responsibilities, professional success, and a drive to create takes immense strength and focus, but how do you keep that balance when you throw running a popular community art center and managing an international charity into the mix? Karen Michel is a crusader for creativity and for living with awareness—both for her fellow man and for the planet that we all share—who still finds ways to fit art-making into her hectic schedule.

INSPIRED LESSONS

Don't wait. It may be days, weeks, or even months before you can set aside a long block of uninterrupted time for creativity, so don't put off your art-making waiting for one. Karen's studio is located in a shared space within the art center she runs with her husband, and she's learned to take advantage of the five-minute windows of opportunity that pop up during her busy days.

Be eco-friendly. The next time you take a trip to your favorite art and craft supply store to restock your studio, consider trading in some of your go-to products for their "green" counterparts. Karen opts for the Earth-friendly supplies whenever they're offered, and has learned that they work as well as the standard versions without the added ecological impact.

Recycle your art. Once a finished piece has been in your studio for a while, give it new life by reusing it in fresh artwork. Karen's art collection doesn't include many of her past creations because she's always finding ways to recycle them into new projects. Some of her paintings are even on their fifth or sixth incarnations.

PAY IT FORWARD

One way or another we all have to find what best fosters the flowering of our humanity in this contemporary life and dedicate ourselves to that.

—Joseph Campbell

37

IN KAREN'S OWN WORDS:
TEACH OUR CHILDREN

Many cities have active art enrichment programs for children, and they're always looking for new volunteers. Lend a helping hand by teaching basic art classes, and make an impact in the lives of our kids. It's important to remember, the children of today are the artists and art

BUILDING HER TRIBE

As a creative individual, you have the power to make a difference by helping to mold the next generation of artists—the children in your community. "When I was a teenager, I realized that my passion for creating was what helped my find my way during a time when most of my peers were completely lost," says Karen. "Art helped me fly above a lot of the nonsense." Now she devotes much of her time to sharing that same lesson with children through her work with the Creative Art Space for Kids Foundation (CASK), a non-profit visual arts center that was founded by her husband, Carlo, in 1996.

In any given week, Karen's art center treats about 60 kids and teens to a diverse curriculum that includes clay, pottery, drawing, painting, and sculpture. But her mission isn't focused solely on providing technical art skills—it's about transforming lives. Says Karen: "All too often, it's the funding for art programs in our schools that are hit the hardest by budget cuts, and it's our children who are paying the price. I believe that there is great power in teaching kids that creativity is part of a happy and healthy life, and that an education that includes the arts is vital for their development."

An idea continues to bloom and flower in the mind of a child long after the seed has been planted. "We've had so many youths come through CASK since it launched," says Karen, "and there's nothing as exciting as when they come in years later, still enthusiastic about their experiences with art, and with us."

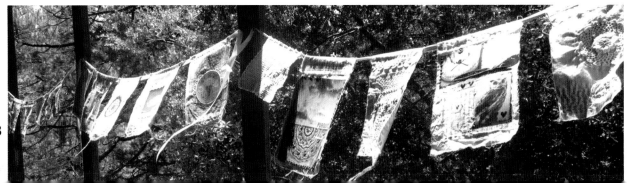

LIVING FOR TOMORROW

A brighter future begins with making a difference today. In addition to their work with CASK, Karen and Carlo also run Haiti Relief Fund, Inc., a foundation established in 2004 to fund humanitarian efforts in Haiti. With the support and contributions of people around the world, they are achieving their mission of fulfilling the most basic needs—food, water, clothing, and medical supplies—of impoverished families affected by natural disasters. By identifying a cause for action and getting involved, they're taking steps to shape the world of tomorrow.

Another way that you can impact the next generation is by being mindful of your ecological footprint. Karen is an avid recycler, and she's been able to find harmony between being an artist and living green. Her passion for working with salvaged materials and planet-friendly products in her art has even led her to introduce a philosophy of repurposing into her art-making process. "I borrow and repurpose bits and pieces from different media, and stitch, glue, and hammer them all into place," says Karen.

Once you've started your own personal revolution, you'll find it hard to stop. Says Karen: "The more you do, the deeper it will take you."

WHEN THE GOING GETS TOUGH

SAYS KAREN MICHEL: "WHEN THE GOING GETS TOUGH, THE TOUGH PAINT SOMETHING."

START A REVOLUTION

If your community lacks a thriving, after-school art program, consider starting one up. Approach libraries, churches, temples, or recreation centers in your area to see if they will allow you to host an art class once a week or a couple of times a month. Many organizations are eager to support the creative development of our youth.

DONATE SUPPLIES

Even if you aren't able to teach an art class, you can still provide support to local programs by donating excess supplies from your personal stash. Gather a box of patterned paper, embellishments, adhesives, pastels, or any other materials that you no longer need, and take them to a school or community center to supplement their existing classes.

39

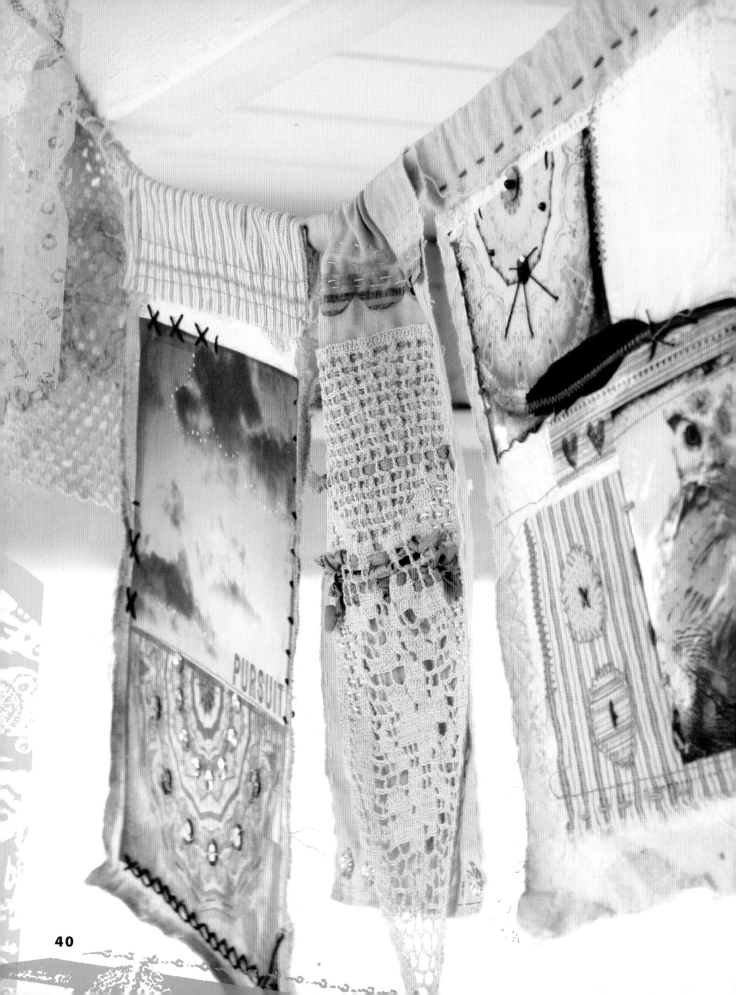

PRAYER FLAGS

When Karen needs to meditate on her thoughts, she turns to an eclectic, mixed-media project like these prayer flags, which she makes from recycled materials. She uses bold stitches to meld together scraps of lace, charming vintage fabrics, and colorful paper prints in order to strike the perfect balance between color and texture.

MATERIALS:

- fabric and lace scraps (such as embroidered handkerchiefs, doilies, patterned cloth, and muslin)

- foam brush

- white gesso

- color copies of photographs and artwork

- embroidery thread and hand needle

- sewing machine and basic sewing supplies

- satin ribbon

- assorted embellishments (such as beads, sequins, and ribbons)

figure 1

figure 2

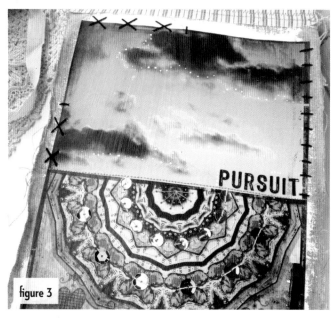

figure 3

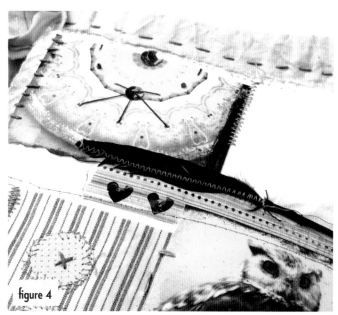

figure 4

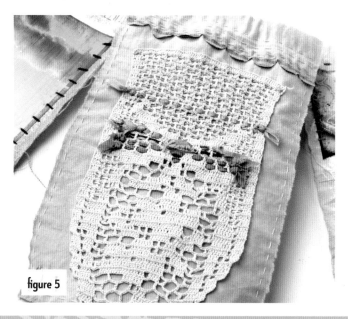

figure 5

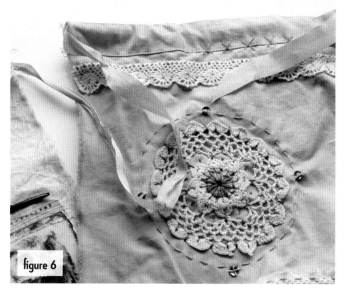

figure 6

figure 7

figure 8

INSTRUCTIONS:

1. Gather fabric scraps both old and new, and cut into rectangular pieces that will be the base panels for the prayer flags. Keep in mind that this final project is one where a piece of ribbon is threaded through all of the flags at the top by turning forward about one or two inches of the panels at the top and stitching down to create a pathway for the ribbon to go through. So if you want the flag to measure 7 inches tall, you will want to cut it so that it is 8 inches tall, to accommodate the extra length that gets folded forward. Also cut smaller pieces of fabrics that you can use to layer and compose designs that you like (figure 1). Ultimately, the size of the prayer flags, and the size of the layered pieces is not an exact science. How big or how little you make the flags is up to you. This prayer flag is 38 inches (97cm) in length.

2. On some panels, you can use a foam brush to apply a layer of gesso and let dry (figure 2).

3. Layer accent pieces onto these treated base panels—adding color copies of photographs and artwork as desired. This step is all about playing around with colors and textures, so don't be afraid to experiment with unexpected pairings. Attach these layers by stitching them in place, either by hand or with a sewing machine (figure 3, figure 4).

4. For the panels that incorporate doilies, have fun by weaving colorful embroidery thread in and out of the open work (figure 5).

5. Cut a piece of satin ribbon long enough to hold all of the prayer flags, with enough excess to leave small gaps between flags. Thread the ribbon through the top portions of all of the prayer flag panels (figure 6).

6. Thread the ribbon in and out of the top edge of a doily to allow the doily to become a flag unto itself (figure 7).

7. With embroidery thread and hand needle, add additional stitched embellishments, such as beads, sequins, appliquéd letters, hand-embroidery, and anything else that you believe would enhance the overall composition (figure 8).

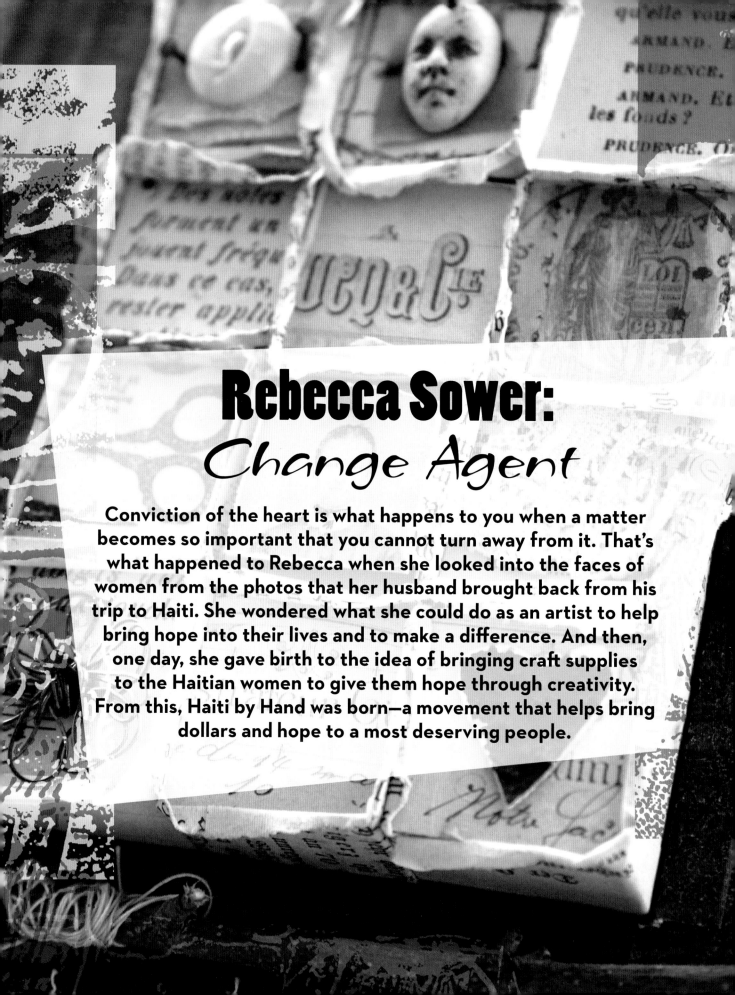

Rebecca Sower:
Change Agent

Conviction of the heart is what happens to you when a matter becomes so important that you cannot turn away from it. That's what happened to Rebecca when she looked into the faces of women from the photos that her husband brought back from his trip to Haiti. She wondered what she could do as an artist to help bring hope into their lives and to make a difference. And then, one day, she gave birth to the idea of bringing craft supplies to the Haitian women to give them hope through creativity. From this, Haiti by Hand was born—a movement that helps bring dollars and hope to a most deserving people.

INSPIRED LESSONS

Take action. Don't just dream of going somewhere and doing something...go there and do it. Rebecca learned this lesson as she finally took the steps to travel with her daughter to Haiti in 2009. By taking action and going there, Rebecca discovered a whole new purpose for using her time and talent to help others.

Be an example. If you want to teach your children to be charitable, don't preach it, inspire it through example. Rebecca has learned that not through her words, but through her actions of being charitable with her time and talent, have her children also come to authentically value charity.

Put one foot in front of the other. When we view people doing big things, it might seem impossible to do the same. But the lesson that Rebecca has learned is that big things start with small steps. Rebecca views herself like everyone else who simply took the first step, and then the next, and then the next.

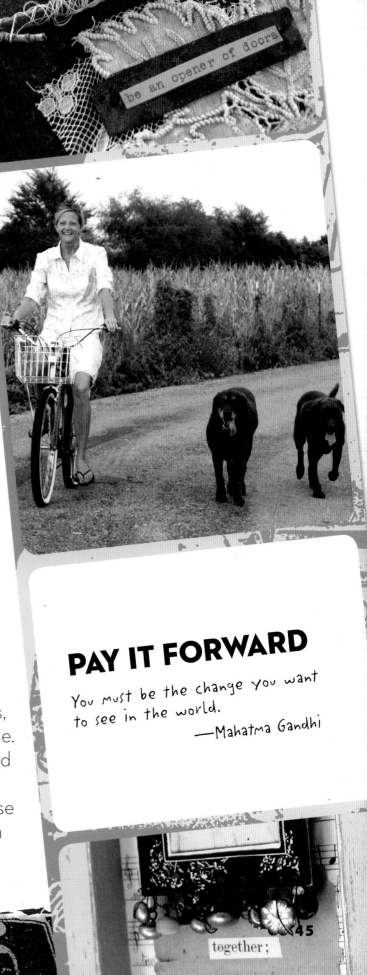

PAY IT FORWARD

You must be the change you want to see in the world.

—Mahatma Gandhi

IN REBECCA'S OWN WORDS: WALK THE TALK

I think we tire of this expression because it's so overused but I do believe that at some point in our lives we all have to take a long hard look at our time and evaluate what we're doing with it. When you live out the changes you seek to effect, you are able to both make a difference and provide a positive example to those around you.

DRIVE TO CREATE

Like most creative people, Rebecca's desire to create is as real and physical as her desire to eat when she is hungry and sleep when tired. "When an idea for a piece appears in my head it works its way down to my fingers and I cannot rest until I go into my studio and pick up my needles and threads and linens and begin creating," she says. "When I am running low on a certain color of thread, I get in my car, drive to the store, and buy more."

With this penchant for creativity as her most obvious offering, she wondered in what way her offering could make a difference for the women of Haiti…women whose faces of hopelessness had become emblazoned in Rebecca's mind ever since her husband had brought back photos of some of the women in a Haitian village during his first service trip to Haiti.

UNIVERSAL NEEDS

The question of how she could help was answered one day when she was standing in the aisle of a large craft store admiring the colors of all the different threads available to her. Then it hit her. Surely there were women in Haiti with the same thirst for creativity who lacked access to crafting supplies. What a gift it would be to find a way to quench that desire by equipping the creative women of Haiti with the most basic supplies like thread, fabric, beads, and needles. "And so that's when I began my work to help at least one or two women of Haiti. I vowed to provide them with what they needed to get in touch with their creativity," she says. "I prayed it would be the path toward providing them with a glimmer of hope."

In 2009, Rebecca traveled with her daughter to Haiti with suitcases filled with beads and threads and all sorts of art and crafting materials. "For several days, my daughter and I sat and crafted with a group of women in Despinos, Haiti…we laughed and sang and stitched and beaded. We prayed and hugged and bonded. And by the end of the week, I was told that we had given these women something they had been void of for a very long time. We had given them hope."

Haiti by Hand has since become an artist group of Haitian women. Rebecca helps this group showcase and sell handcrafts through Etsy, with 100 percent of proceeds going directly to benefit the Haitian artisans. To date, Haiti by Hand has raised more than $13,000 for the artisans of Haiti.

Rebecca is gratified that artists can use their art for good and explains that "at the end of the day, what we've done for others will shine so much brighter."

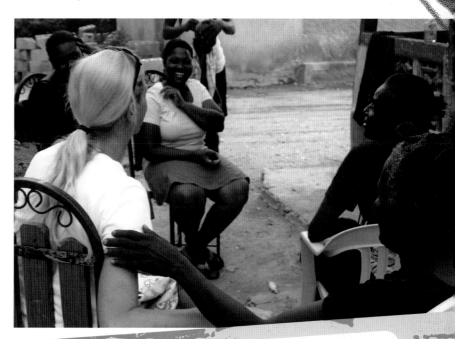

REACH ONE

There are millions of people around the world who need your compassion, and although you can't help them all, you can make a huge difference in the life of one. I know that I cannot solve the problems in Haiti, but I can help give hope to a small handful of women. My dream is that these women then spread this same assurance to their children, and that the impact is felt for generations.

LET GO

All of us have something in our lives—something that we don't need—that is consuming a portion of our time and money. Determine what that thing is, let it go, and use that time and money to touch someone's life.

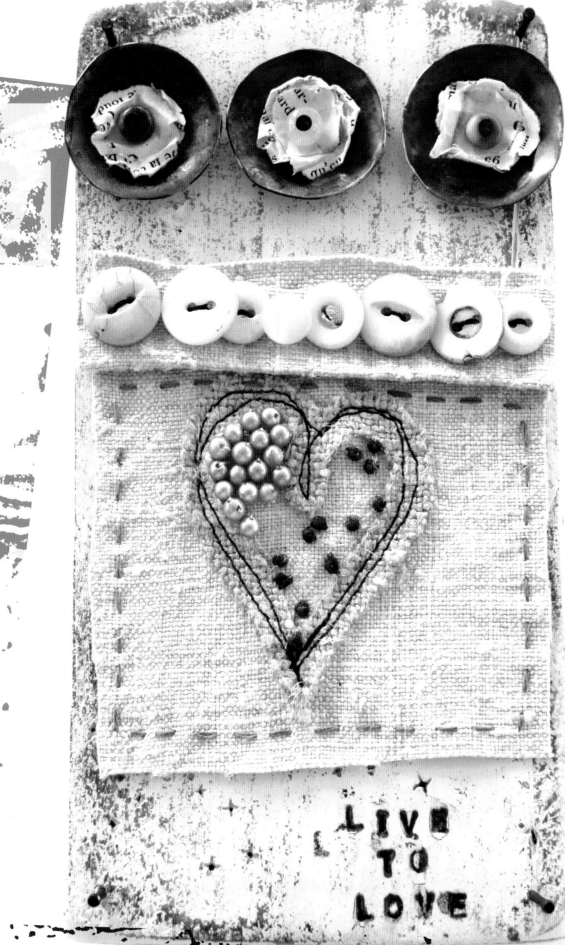

LIVE TO LOVE

This wood block collage incorporates many of Rebecca's favorite elements including fabric, buttons, beads, paper, and metal. The text is added with metal stamps that get punctuated with just a touch of dark paint. It is the perfect project where treasured bits and pieces can come together to make a lasting impact.

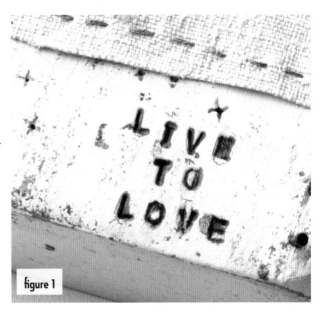
figure 1

MATERIALS:

- wooden block (scrap lumber)
- artist's acrylic paints
- sandpaper
- metal stamps and hammer
- matte spray sealant
- small nails
- oxidizing solution
- thin copper sheeting
- dapping block (jewelry supply store)
- book pages
- jeweler's hammer
- vintage linen remnants
- vintage mother-of-pearl buttons
- embroidery thread and hand needle
- beads

INSTRUCTIONS:

1. Apply several coats of artist's acrylic paints, ending with the final coat in pale yellow. Once dry, sand the block, 3½" x 6½" x 1½" (9cm x 17cm x 4cm), to give it a distressed effect.

2. Use metal alphabet stamps to create the words "LIVE TO LOVE" on the bottom portion of the block. Paint over the words with a dark paint, making sure you fill in all the words. With a damp cloth, wipe away all excess paint. Spray entire piece with matte spray sealant (figure 1).

3. Cut a heart from a piece of heavy linen and free-motion stitch onto a rectangular piece of heavy linen in a slightly contrasting shade. Cut out interior of the heart and add hand-stitched French knots and beading (figure 2).

4. Attach another piece of fabric to the top edge by sewing on a row of vintage mother-of-pearl buttons. Use spray adhesive to adhere this small fabric collage onto the prepared wooden piece.

5. Cut three 1½-inch discs from thin copper sheeting (oxidize if desired) and hammer into bowl shapes using a dapping block. Layer copper disks with torn book pages and beads, and secure them to the wooden block by hammering the layers with small oxidized nails. Attach nails to each corner of the piece (figure 3).

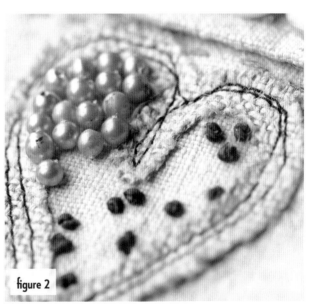
figure 2

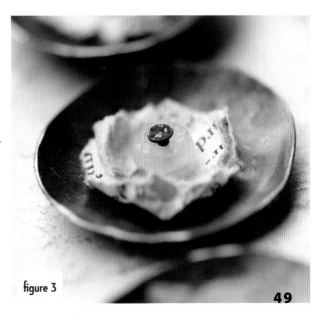
figure 3

Michael deMeng:
Artist

When you understand the importance of art, you make a decision to pursue it, even when it feels daunting to do so. This decision is one that Michael made one night years ago, as he lived tending bars 20–30 hours a week, and making art 40 hours a week. It was a midnight brightly lit by the full moon when he decided that even if he might never find acclaim, even if he had to tend bars for the rest of his life, art would remain his pursuit. Shortly after this fateful night, doors started opening. And success started happening. Today, Michael seeks to find ways for others to discover the power and faithfulness of art.

INSPIRED LESSONS

Learn. Without soul, art remains hollow. But don't underestimate the importance of learning and understanding the mechanics and the history of art. Michael credits his art professor Robert Kiley for teaching him to understand paint and to find inspiration from the utilitarian aspect of art-making.

Go. Sometimes, to find inspiration, you need to spread your wings and push yourself to experience new destinations. Michael credits his art instructor Don Bunse as the one who inspired him to travel to Mexico. In Mexico, Michael discovered a culture that has been integral in his development as an artist and person.

Create value. The price tag on a piece of art does not necessarily reflect its value. For Michael, value is created when an art object or artistic process can create an experience that fulfills people. Michael has learned that artistic platforms that can be both inclusive and integrated into everyday life are what create the greatest value.

PAY IT FORWARD

Full fathom five thy father lies,
Of his bones are coral made:
Those are pearls that were his eyes,
Nothing of him that doth fade,
But doth suffer a sea-change
Into something rich and strange
Sea-Nymphs hourly ring his knell.
Harke now I heare them, ding-dong, bell.

—William Shakespeare

LASTING CONTRIBUTIONS

Giving something of value to the world is Michael deMeng's aim. His mother, he explains, has given the gift of her children to the world. And as a child of hers, he also explains, he received unconditional and endless support from her throughout his childhood, to equip him with everything that he would need to create what he loved most: art. "It's not that she encouraged me to be an artist, but rather, she encouraged me to do what I wanted to do," he says.

Michael explains that unlike his mother, children will likely not be his contribution to the world. But he hopes that through his art, he can give something of value to the world. "I want my art to have resonance beyond my life…beyond being just the flavor of the month…something that has long-standing impact in some capacity."

IN MICHAEL'S OWN WORDS: CREATE A VENUE

There is one thing that I have done that I think gives me the most gratification. It is an arts event that my friend Bev Glueckert and I founded over 15 years ago, The Festival of the Dead. It is a community event inspired by the Latin American festival, Day of the Dead, where people from the community gather to artistically remember those who have passed. I love the concept of creating a venue that is artistic in nature that allows others to participate in their own artistic versions of it. Create a venue for community participation and you will create societal value.

INESCAPABLE JUXTAPOSITIONS

Michael's body of work is described by many as "dark," to which Michael doesn't disagree. "My art tends to be on the shadier side of things," he says. "Blight becomes more light when surrounded by shadow. Truth can be so harsh sometimes…a little bit of mystery can make the world more palatable and enticing. Offering up mystery and darkening the arena…I try to make things nebulous so that people have to look and find understanding rather than have it given to them on a platter."

In order to find inspiration rather than have it handed to him, Michael has spent much time exploring Oaxaca, Mexico—a land with a humble and celebratory people that has become a muse of sorts, and illuminates his artistic path. "I know that Mexico has violence and corruption and darkness. But in Mexico, art is for everyone," says Michael. "People in Mexico know who their favorite poet is…art is valued in Mexico…whether the person is an artist or the person just values reading poetry or listening to music…art is an integral part of living."

Joy in the midst of corruption. Light diffused by a soothing shadow. Death celebrated in life. Art created through struggle. The beauty of these inescapable juxtapositions found in all facets of life are what fascinates Michael and what he hopes will be found in his art and by the students he teaches.

BE A GOOD TEACHER

I have to give Teesha Moore credit for allowing me to reinvent myself. She is the one who opened up the teaching arena for me that I never understood. What I now understand is that it's important for teachers to have tangible knowledge about techniques that can be taught. But teachers also need to have empathy and the ability to gauge students' struggles that are not about techniques. It's important to hear what students are saying, and to help them feel understood and to help them resolve assorted life struggles through their art.

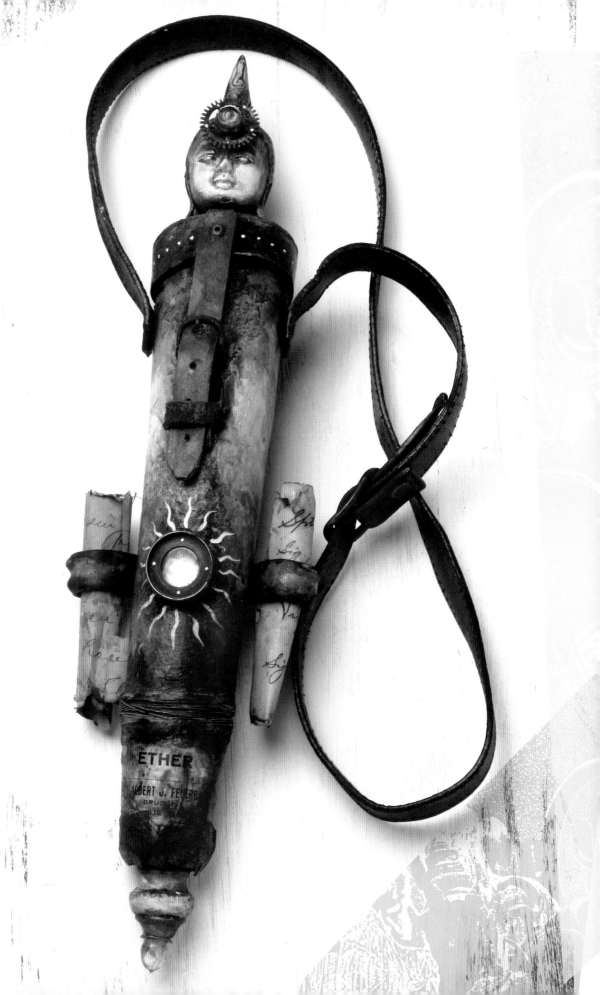

PRAYER KEEPER

This altered vessel all began when Michael found in Sydney, Australia, an unusual leather container—likely a container for a surveying tool from the 1930s. Because Michael's works are made with such one-of-a-kind elements, it is almost impossible to duplicate the final project. However, Michael offers some general instructional approaches for this project that can be applied to other types of vessels or suitcases that can be altered in similar fashion.

MATERIALS:

- vessel (such as a purse, suitcase, or pouch)
- strong-hold glue (E-6000)
- head from a doll or statue
- drill
- gears and bolts
- epoxy clay (Aves)
- acrylic paints
- paintbrushes
- embellishments (like eyeballs, and glass vials)

INSTRUCTIONS

1. Gather gears and bolts and other embellishments of your choosing and start attaching them to the vessel. The methods of attachment could include drilling and bolting down, or using a strong-hold glue like E-6000, or using a 2-part epoxy clay. The clay Michael uses is manufactured by Aves (*www.avesstudio.com*). Once the two parts are mixed together, you can use it to sculpt and mold objects like a doll's head directly onto the vessel (figure 1). The clay dries in about 2–3 hours and completely cures in 24 hours.

2. Once all of the items have been attached and everything is dry, add washes of color with acrylic paints. Finding the right color combination is something that happens with practice (figure 2). Experiment with colors to discover your favorites for adding the right accents to this project.

3. Once the color is fully dry, you may want to attach just a few more objects that are not treated with any of the colors, which will brighten up and add energy to the piece (figure 3).

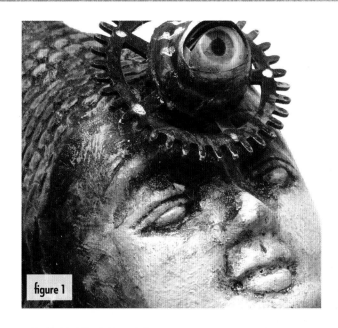

figure 1

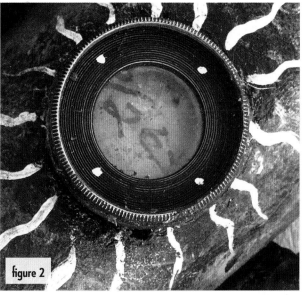

figure 2

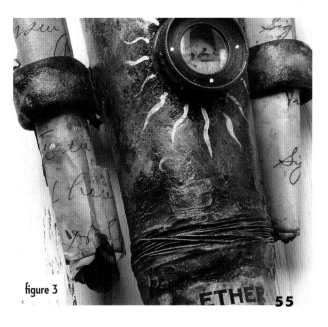

figure 3

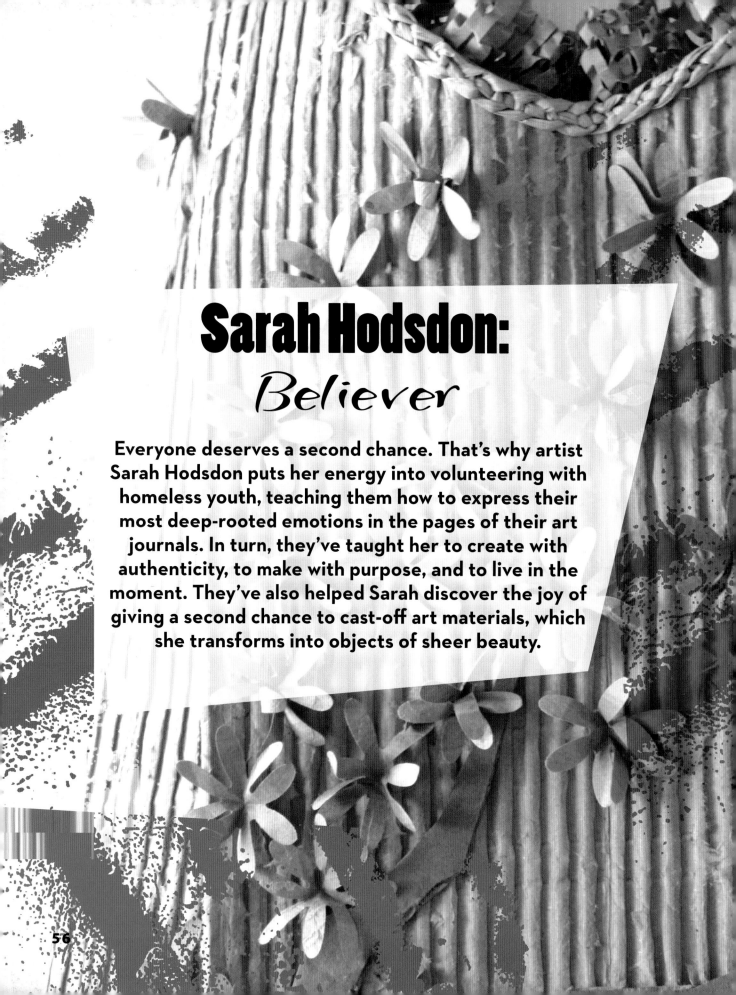

Sarah Hodsdon:
Believer

Everyone deserves a second chance. That's why artist Sarah Hodsdon puts her energy into volunteering with homeless youth, teaching them how to express their most deep-rooted emotions in the pages of their art journals. In turn, they've taught her to create with authenticity, to make with purpose, and to live in the moment. They've also helped Sarah discover the joy of giving a second chance to cast-off art materials, which she transforms into objects of sheer beauty.

INSPIRED LESSONS

Art is contagious. Once someone has been equipped with the confidence and skills to make art, they can't keep it to themselves. If you spend time teaching someone basic art techniques, they'll soon start sharing that gift with others. Sarah actively volunteers at youth programs by teaching art classes, and she has watched many of her students go on to teach art to others.

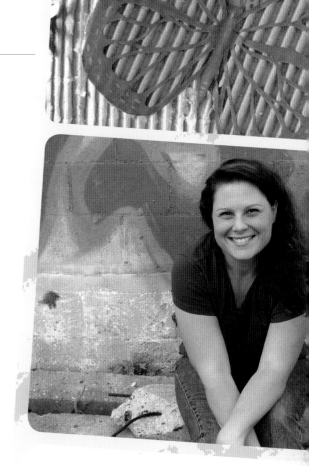

More than words. You don't need to be able to read or write to engage your creative side, because art is a universal medium that transcends language barriers, and connects people and their stories in profound ways. Sarah has worked with children who struggle to communicate due to illiteracy, but have been able to find their voices through art.

Distinguish between personal and public. If you are in the business of making art, sometimes it can be difficult to use the creative process as an outlet for the stresses in your life. Create a distinction between your "public" art and the works you create for yourself. Sarah uses her personal art to explore techniques and play with new materials while taking a break from her professional responsibilities.

PAY IT FORWARD

If you can talk with crowds and keep your virtue,
Or walk with kings—nor lose the common touch.

—Rudyard Kipling

IN SARAH'S OWN WORDS:
INVEST IN SOMEONE

A caterpillar does not announce what it will become any more than a homeless or orphaned teenager will. People can rise above incredible hardship to create the lives they imagined when others see them as valuable enough to invest in. Contribute artistically, financially, or simply by being a mentor, and let someone know that you believe in them.

HELP TO TELL A STORY

Everyone has a story to tell, and art is an ideal medium for storytelling. Help someone get their tale out into the world by encouraging them to make a piece or a series of artwork that captures their journey, providing supplies and basic instruction if necessary.

BREAKING DOWN BARRIERS

Imagine for a moment that you didn't know how to read or write. How would you tell the world your story? In her work with disadvantaged youth, Sarah has discovered that a single piece of art can convey more than words ever could, and that the act of creating can give people the courage to open up. "A simple stick figure can reveal more of a person's soul than a thousand words; it can penetrate barriers, break down walls mortared together by hard lives and a jaded existence," says Sarah.

Believing in a person, especially someone who feels a lack of support, is one of the most powerful gifts that you can give. Sarah invests in the children that she teaches—she takes an active interest in what they make, shares her creative expertise, and provides the encouragement that many have been missing in their lives. "You don't need to be a giant among a multitude of men to inspire greatness," says Sarah. "It can be as simple as making those around you feel as if they are the giants and able to do great things in your presence."

GIVING NEW LIFE

Like the transformations that Sarah inspires in the youth she teaches, she also creates beauty from materials that are too often disregarded. Her work with salvaged and recycled cardboard has won awards, but it's the concept of making the most of what she has that Sarah values most. The apron shown here is made of recycled cardboard and packaging materials that celebrate Sarah's point of view. "Dump out your junk drawer, take a few deep swallows of coffee, and make something functional using nothing but what you have on hand," she says.

Sarah's philosophy of using her resources wisely also extends to her body of training, which includes textiles, sewing, crocheting, wood-working, and even metal-smithing. A diverse background that incorporates a wide array of skills, including those of the non-artistic variety, is great preparation for inspiring others through art. "Mentors don't wear hats, they wear work gloves," she says.

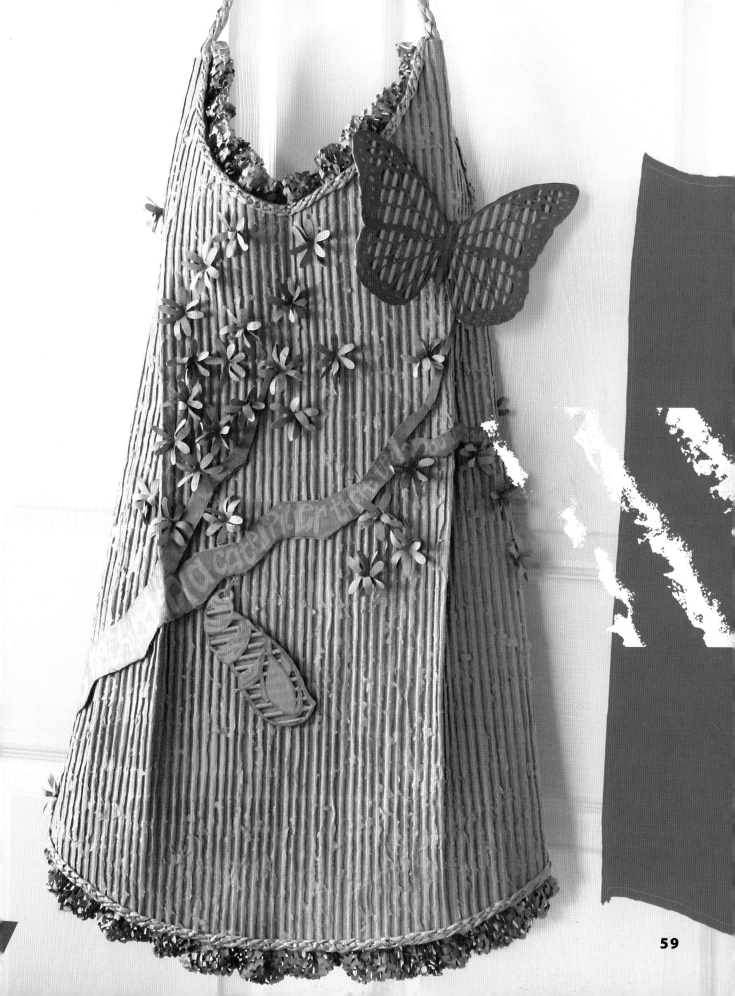

Suzi Blu:
Survivor

Imagine being so stricken by fear that basic activities like riding in a car or eating solid foods were not just difficult, but were completely unbearable. That was Suzi Blu's reality for 12 long years, as she battled debilitating panic attacks and an eating disorder that left her unable to keep a long-term job or hold any meaningful relationships. But then she discovered mixed-media art. With ink-stained hands and a floor covered in glitter, Suzi literally transformed her life one project at a time. Now she is a thriving artist with an infectious spirit who actively works to teach others how to use art to overcome the challenges in their own lives.

INSPIRED LESSONS

Write your story. Use your words to tell your story, and to uncover what is behind the emotions that you feel. During the time when Suzi was struggling with depression and anxiety, her journals were her friends, her confidantes, and ultimately her sources of strength and personal discovery.

Make your own schedule. Listen to your inner clock and learn to work at the times that are best suited to your personal preferences. When it comes to writing and sketching, Suzi is most productive in the half hour right before she falls asleep, because she's more open to new ideas than at other times of the day. She reserves her mornings for working on paintings or editing final drafts, since they require a technical touch.

Focus on your materials. Don't let your expectations of what a finished project should look like interfere with the experience of making art. If Suzi notices doubts and fears beginning to creep in while she's in the midst of creating, she focuses her attention on the materials that she's working with...what they feel like in her hands and what effects she can achieve with them. This allows her to loosen up and begin playing, which is when her real breakthroughs happen.

PAY IT FORWARD

The best thing about the future is that it comes one day at a time.

—Abraham Lincoln

WISH

WHEN THE GOING GETS TOUGH

SAYS SUZI BLU: "WHEN THE GOING
GETS TOUGH, THE TOUGH GET
QUIET. I BELIEVE THAT WE ALL HAVE
THE ANSWERS INSIDE OF US TO ANY
CHAOTIC SITUATION BUT WE
WON'T BE ABLE TO HEAR WHAT
WE NEED TO DO IF WE DON'T
SETTLE DOWN AND LISTEN."

FINDING HER SHINE

Before Suzi found the world of mixed-media art, she expressed herself through the pages of her journals. "At first, everything I wrote was negative," says Suzi, "but over time my writing began to convey truths that I hadn't allowed myself to see. When I slowed down to create words, I turned off the outside world and for the first time I heard what was within." And what was within was a scared girl who was desperately seeking an outlet for her anxiety.

The first time she held a paintbrush in her hand, Suzi knew she had found the outlet she had been looking for. She didn't set her sights on making great art initially, because she didn't want painting to become another cause of stress in her life. Instead, Suzi allowed herself to make art that was simply about expression. "Art therapy is something we all can do," says Suzi. "Get crayons and color your anger, put a shape to your sadness. Get out of your head, and make art as if you're going to throw it away."

Regardless of the medium you choose or the subject matter you focus upon, your art is a reflection of how you feel at the moment you sit down to create. Suzi describes the subjects of her paintings as "pretty girls who have been through the wringer," but there's always an element of strength, protection, or happiness that flows through each piece. She says: "I started painting to work my way out of sadness, and although I'm not sad anymore, there are parts of me that are still broken. But my broken parts do not define me...I still shine."

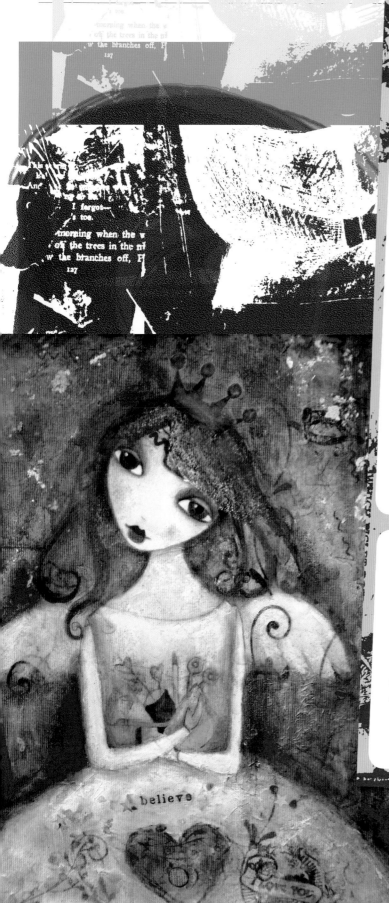

IN SUZI'S OWN WORDS:
DONATE A DAY

You don't have to have money to give money. I spent my 43rd birthday teaching an art class as a fund-raiser for Holly's Garden Rescue, a local organization that rescues dogs from shelters. My darling Shih-Tzu, Finnegan, was saved by this group, and I wanted to find a way to support them. I had a total of 12 students enroll in my course, which focused on painting and sketching, and was able to raise a total of $540 to give to Holly's Garden Rescue. Holding this class only took one day of my time, but it meant the difference between life and death to the dogs that were directly helped by my contribution.

JUST 24 HOURS

Imagine how much good we could do if everyone spent one day, just 24 hours per year, working toward a cause. When you give, you become larger than you are, and you change the world.

Many of Suzi's paintings are of pretty girls who she describes as "having been through the wringer." They are works that have helped Suzi work through her own sadness and emerge with strength and resilience.

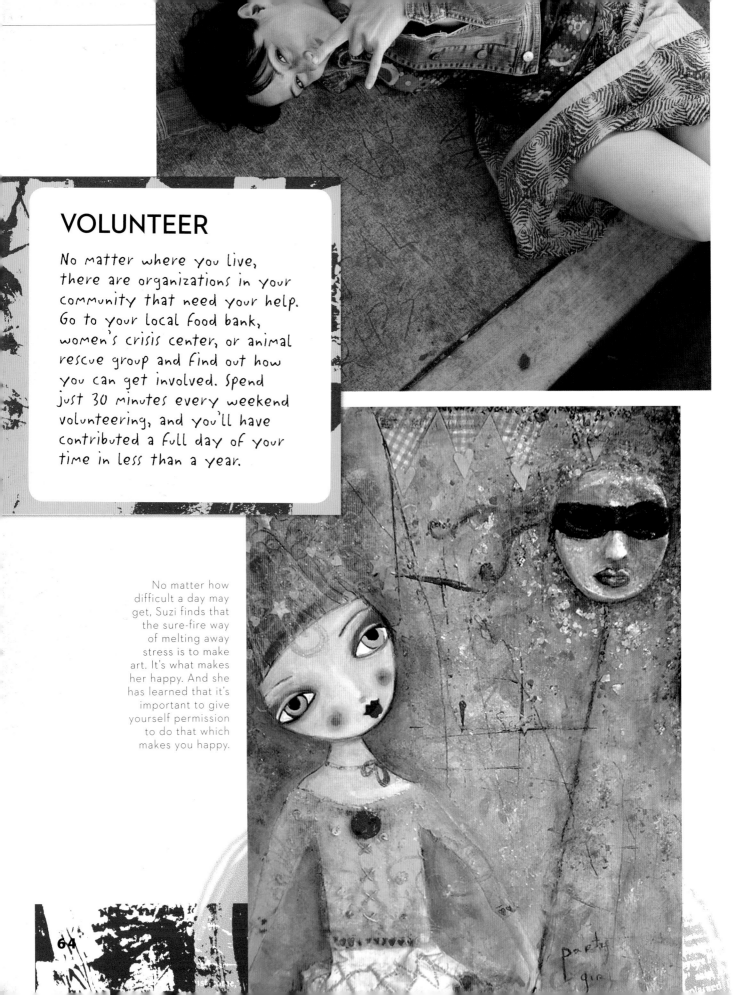

VOLUNTEER

No matter where you live, there are organizations in your community that need your help. Go to your local food bank, women's crisis center, or animal rescue group and find out how you can get involved. Spend just 30 minutes every weekend volunteering, and you'll have contributed a full day of your time in less than a year.

No matter how difficult a day may get, Suzi finds that the sure-fire way of melting away stress is to make art. It's what makes her happy. And she has learned that it's important to give yourself permission to do that which makes you happy.

PRACTICE MAKES PREFECT

Like learning to play a flawless violin concerto or bake the perfect soufflé, it takes practice to become the best artist that you can be. Once Suzi had conquered her disorders, she turned her attention toward developing and refining her signature artistic style. "The stigma is that talent is something you were born with and if you weren't sketching like da Vinci when you were five years old then it's a waste of time to make art," she says. Despite her late entry into the medium of painting, Suzi established her own distinct variety of portraiture—a colorful, expressive form that has struck a chord with art fans and made her a highly sought-after art instructor.

A common misconception held by many artists is that creating is a selfish activity. During the workshops she teaches, Suzi has heard this sentiment echoed by her own students, who feel guilty for taking time to make art. Says Suzi: "A big part of the payoff of being an art teacher is the influence I have on changing people's minds about the importance of making art. When you create from an authentic place, you make the world a better place." In short, life is more than mere survival...it's about doing the things that make you happy too.

LIVING IN THE MOMENT

Whether you choose to pour your heart into the pages of your journal or splatter paint onto a canvas, indulging your artistic passions helps you live in the now. Through her paintings, her workshops, her blog, and her wonderfully quirky online videos, Suzi has conquered the disorders that once held her captive and established a worldwide fan following in the process. She currently spends the bulk of her time creating in her "gypsy wagon" with her beloved rescue dogs, Gigi and Finnegan, at her side. Suzi still has difficult days from time to time, but as long as she has her art, she'll be OK. Says Suzi: "When I get stressed, my wheels spin and I pace and think and plan and obsess and worry. But then I sit down, make art, and all of that just melts away."

THROW A PARTY

Invite all of your friends over for a dinner party, and ask them each to bring a dish and a $10 bill. You'll have the opportunity to share some laughs and great food with the people you love, and at the end of the evening, you'll be able to donate that money to a worthy cause. Plan a six-hour party every three months for a year, and you'll have given 24 hours of your time.

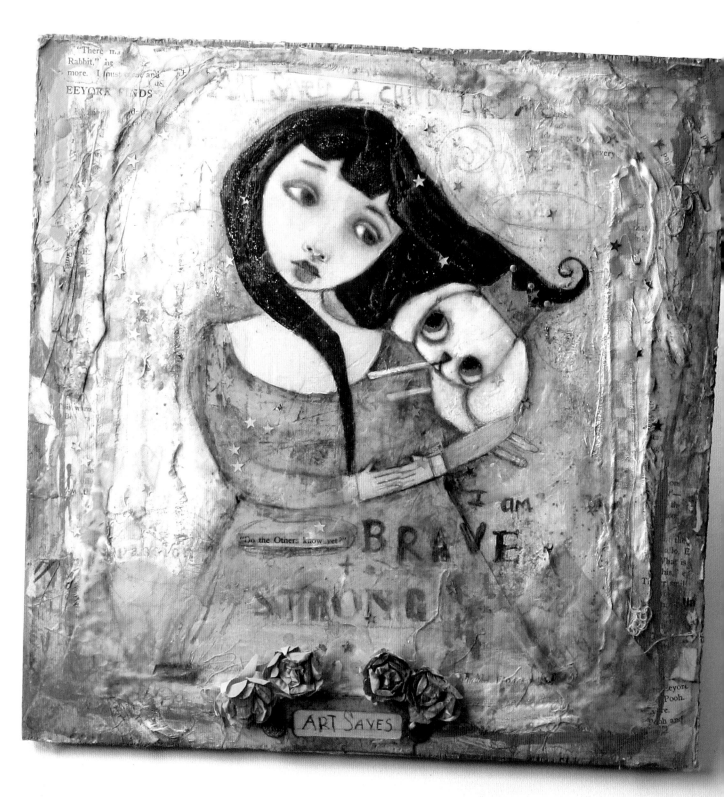

ART SAVED A CHILD LIKE ME

With its combination of vibrant colors, complexity, and heart, this mixed-media collage by Suzi is the embodiment of the artist herself. The project starts with an original self-portrait, which she then elevates by adding layers of paint and vintage text before fusing it all together with a generous coating of beeswax. Because of the way that this project is structured—beginning with a base sketch and adding details in stages—the sophisticated final result can be achieved by artists of all levels.

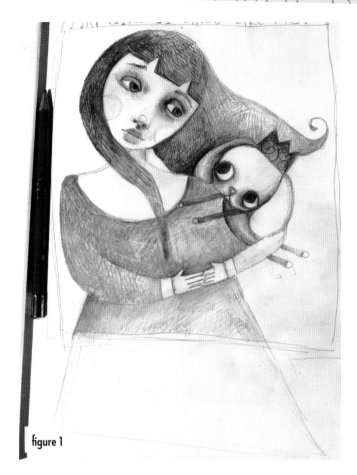

figure 1

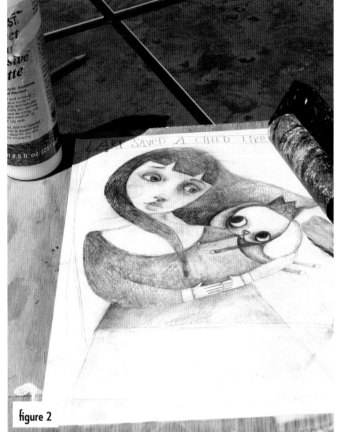

figure 2

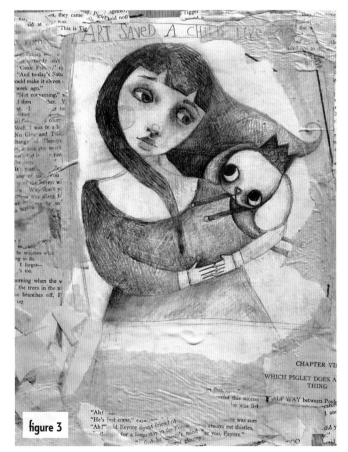

figure 3

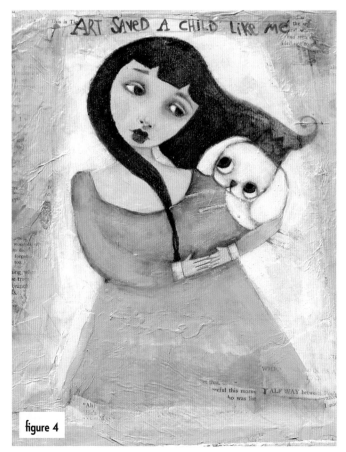

figure 4

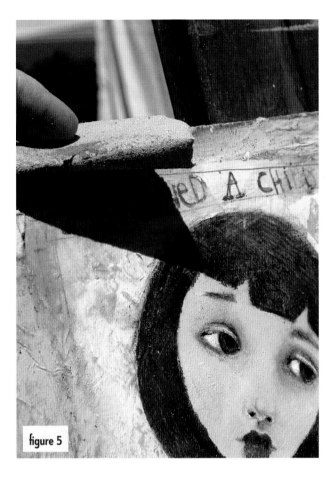

figure 5

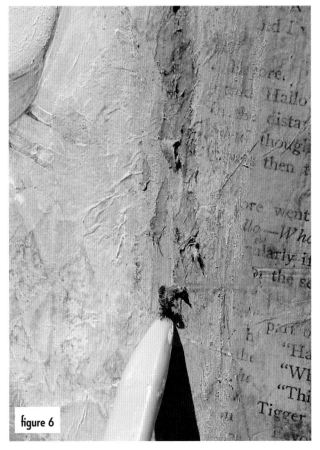

figure 6

MATERIALS:

- drawing paper
- pencil
- stretched canvas or piece of wood
- matte medium: archival quality
- brayer
- vintage text sheets
- artist's acrylic paint
- rubber stamps & stencils: assorted
- paintbrushes
- sandpaper
- beeswax
- small quilting iron
- soft cotton cloth

INSTRUCTIONS:

1. Use a pencil to sketch figures onto a sheet of drawing paper. An alternative for beginners is to doodle simpler shapes like hearts and flowers (figure 1).

2. Use matte medium to affix the sketch onto a stretched canvas, or a piece of wood 12" x 12" (30cm x 30cm). Use a brayer to remove any air bubbles and ensure a smooth surface (figure 2).

3. Tear sheets of vintage text into small pieces, and layer them around the figures to create a background (figure 3).

4. Fill in the figures using colored pencils. Be sure to cover the areas that will not be painted (such as the skin and hair), as the colored pencil markings will help protect the paper from the hot wax used later in the project. Use acrylic paint to decorate the clothing on the figures. Embellish the background using acrylic paint, rubber stamps, and stencils. Use a paintbrush to add text as desired (figure 4).

5. Once dry, carefully sand the edges to remove any excess paper that hangs over the base surface (figure 5).

6. Use the handle of a paintbrush (or any other pointed tool) to scrape through the layers of paint and paper that make up the background, creating a distressed look (figure 6).

7. Lightly wipe away any fibers left behind from sanding and apply a coat of hot beeswax. This can be done by first placing small pieces of beeswax onto the collage and then melting the pieces by placing a small heated quilting iron over the wax pieces and gently spreading the wax across entire piece. Once finished, use a soft cotton cloth to lightly buff the beeswax to create a polished, shiny finish.

Stephanie Lee:
Grounded

What comes first...the art, or the experience that inspires the art? The answer to this is at the core of Stephanie Lee's foundation upon which she aspires to authentically build the many facets of her life. The answer is about balance, about finding ways to be fully present in all that she does—whether it is tending to her family or creating something from the heart. Through balance, Stephanie believes that true success can be had, which she defines as the ability to be in love with and uplifted by what she does and makes.

INSPIRED LESSONS

Be inquisitive. When you are curious enough to ask and explore answers to questions, truly innovative discoveries and artistic breakthroughs are made. Stephanie has learned this lesson time and time again as she continues to push the envelope in her creative process as she asks herself "what if" questions regarding the tools, materials, and techniques related to her art.

Write with honesty. Writing your thoughts down in a journal with honesty, and without worry of having the journal perform in front of anyone by way of publication or display, is an important way to center yourself. Stephanie has learned that this sort of journaling—not to be confused with art journaling—is an effective way to stay grounded each and every day.

Enjoy the gift of creativity. In this fast-paced world, as we juggle many deadlines and projects, it's easy to get caught up in "keeping up" rather than truly savoring and appreciating creativity. Stephanie has learned that for her art to be real and meaningful, she's got to create without worrying about "keeping up" or "measuring up," but truly enjoying the gift of creativity.

PAY IT FORWARD

A warrior must learn to make every act count, since he is going to be here in this world for only a short while, in fact, too short for witnessing all the marvels of it.

—Carlos Casteñeda

IN STEPHANIE'S OWN WORDS:
BE A CHAMPION FOR SOMEONE

Remember that it takes very little to lift a spirit. Pay attention to who among you could use an encouraging word. It might be as simple as expressing admiration for their perseverance. It might be commending their way with using color in a painting. It might be simply putting your hand on their shoulder and letting them know that they will find solid footing soon and in the meantime, they can relax.

KEEP IT SIMPLE, BE SPECIFIC

Don't let a self-imposed expectation of "bigness" trip you up. A small word, shared from the heart sincerely, can move mountains of doubt in the heart of another. It may not be immediate, but know that the smallest act of encouragement will act as a fault line that will shift the plates in time, allowing growth to emerge in the cracks.

DEFINING SUCCESS

Before striving for success, it's important to define it. Because if the pursuit of success is one that has been constructed under somebody's terms, it becomes a fruitless pursuit. Stephanie Lee has come to a point in life where rather than measuring success solely on financial gain, she elects to measure it by the amount of joy she gains from enjoying her creative self. "I define success as being in love with and uplifted by what I do and make," she says. Being in love with what she does means that Stephanie is often trying out new techniques and experimenting with mixing materials. "I bounce around," she says. "Plaster to metal to paint to jewelry, and back to plaster…a little plaster in jewelry, a little metal filled with plaster, a painting on plaster, metal over paint." This multi-faceted approach has allowed Stephanie to develop a voice that is completely her own, and one that she is proud to describe as slightly south of mainstream.

WHEN THE GOING GETS TOUGH

SAYS STEPHANIE LEE: "WHEN THE GOING GETS TOUGH, THE TOUGH KEEP MOVING FORWARD. THEY ARE VIGILANT WITH INTERNAL INQUIRY TO KEEP THEIR FOOTSTEPS ON THE PATH OF PURPOSE, INTENTION, AND HONORING THEIR CREATIVITY IN ALL ITS MANY FORMS."

SOUTH OF MAINSTREAM

Interestingly, mainstream is where she sought to stay for much of her life, as Stephanie resisted all the early signs that were steering her toward a less traditional and more creative path. Finding the strength to accept her need to create was the first step in discovering the beneficial qualities that it holds. "For all the years that I was conflicted about how art fit into my life, I wasn't able to see the healing power of it," she says. "I just knew it was calling to me and that I couldn't ignore it."

It wasn't until she started teaching art that she was able to fully appreciate how the power of art can impact people's lives. Specifically, it was a tearful "thank you" expressed by a student who had attended one of Stephanie's workshops that became a catalyst for this realization. "Certainly she was expressing the power it was having in her heart but little did she know that in that sharing, my energy in teaching something that I wondered if anyone would want to know became valid," says Stephanie. "There is power for healing and strength in me just knowing that what I am doing, however insignificant it may seem to me, has a profound effect on those I share it with."

FULLY PRESENT

Validation and meaning derived from the artistic process strike an interesting balance with Stephanie's obligations to her family. "In all my efforts to include my children in my creative process, there have been seasons where my energy needed to just be fully present in wiping noses, swimming in the river, and such," she says. Likewise, being fully present with her art requires Stephanie to resist mainstream measurements of doing things better and faster. Rather she takes an authentic, curiosity-based approach where she allows herself to ask "what if?" questions…as she remains alert and fully present to experience the outcome, regardless of how quickly the answers come.

73

HEARTSPACE

The process of asking "what if" questions within art allows Stephanie to achieve new effects that wouldn't emerge if she didn't pursue such questions. This mixed-media painting incorporates some of the special effects that Stephanie unearthed as she mixed paint with plaster, dots with words, dreams with good intentions.

Photo by Judy Wise

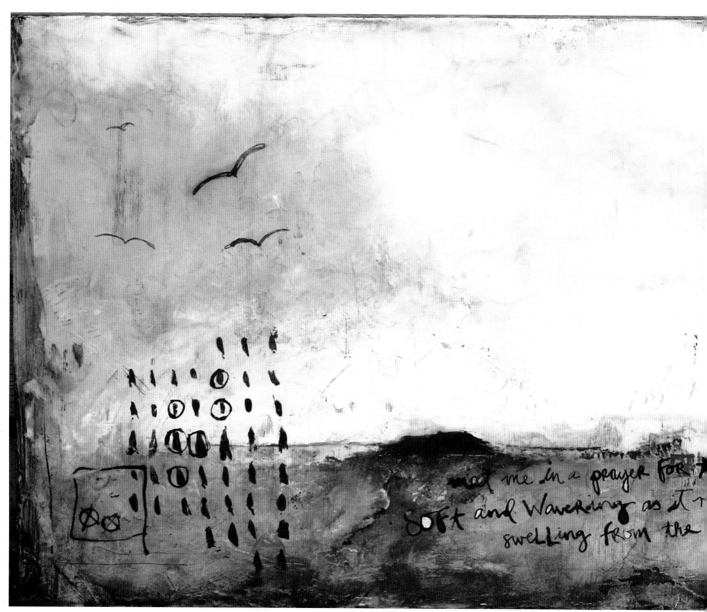

MATERIALS:

- wood panel (or other sturdy substrate)
- plaster
- trowel
- acrylic paints
- white gesso
- Raw Umber acrylic wash (mix one part paint with four parts water)
- towel
- paintbrushes
- water-soluble crayons (Caran D'Ache Neocolor)

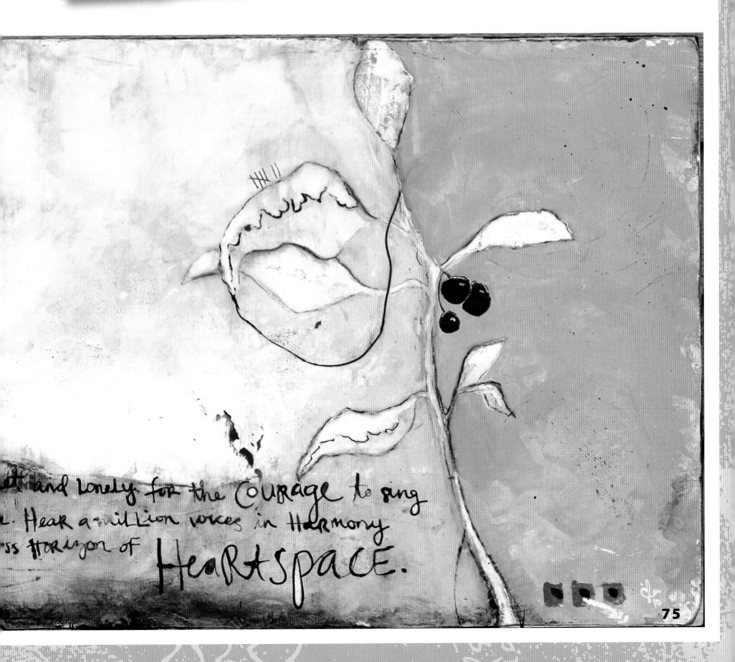

figure 1

figure 2

figure 3

figure 4

figure 5

figure 6

figure 7

figure 8

INSTRUCTIONS:

1. Select a substrate upon which you can lay down a layer of plaster. This piece measures 60" x 24" (152cm x 61cm). Use a large trowel to lay down the plaster, embracing all of the imperfect texture that plaster creates (figure 1).

2. Once dry, use a trowel to lay down acrylic paints in strategic areas. Remember to go slowly and build gradually, and to stop when you feel you have created a pleasing tone (figure 2).

3. Once the acrylic paint is dry, add more layers with white paint or white gesso, to create added depth and interest (figure 3).

4. On certain spots along the edges of your piece, apply Raw Umber acrylic wash with a paintbrush to add deep accents (figure 4). Using a towel or old rag, blend and wipe off excess (figure 5).

5. With a small paintbrush and an unexpected accent color, add dots or other markings as desired (figure 6).

6. With a water-soluble crayon, draw silhouettes of leaves or other objects as desired (figure 7).

7. With a medium paintbrush, apply thick and textured applications of white paint within the silhouette outlines (figure 8).

8. Use a water-soluble crayon to add a message onto the piece. Embellish the lettering and the leaves with colorful accents to finish.

Susanna Gordon:
Winged Messenger

Art speaks in many ways. It can be used to tell stories, express emotions, and give a voice to those without one. Susanna Gordon's art is about delivering messages to people who need them, messages of hope that inspire thought and promote positivity. Her instantly-recognizable "winged messengers" have traveled to Kenya, France, Denmark, and even the Great Wall of China. They've made people smile, they've made people ponder, they've brought together a group of artists from around the globe...and it all started with a piece of art and an idea.

INSPIRED LESSONS

Get distracted. Instead of letting yourself fixate on the parts of your life that cause you stress, give your mind room to wander. Susanna's favorite way to escape is to grab her camera and head out for a walk in a local park. She allows herself to soak in her surroundings, and quickly finds herself too distracted by the beauty around her to focus on whatever had been worrying her.

Take advice. Being on the outside looking in can provide unique insight, so if someone you trust offers you advice, consider taking it. Susanna's decision to pursue higher education in the arts was influenced by an admired teacher, who urged her to submit a portfolio to a nearby art & design college. The recommendation was spot-on. Susanna wound up attending that school, where she discovered a passion for photography.

Make it happen. Everyone has something to contribute to the greater good, and it's up to you to get out there and do it. Once Susanna had developed the idea for her winged messenger project, she didn't wait to get it off the ground...she jumped right in, and began leaving her inspirational art pieces around her own neighborhood before branching out to the far corners of the world.

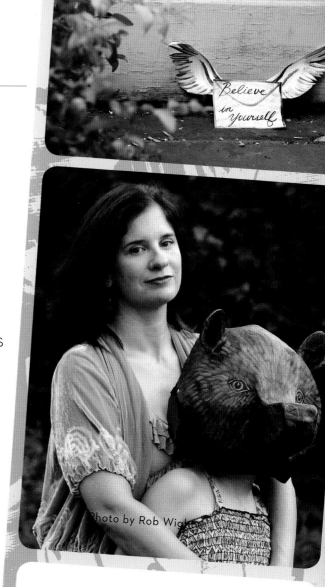

Photo by Rob Wight

PAY IT FORWARD

Few things in the world are more powerful than a positive push. A smile. A word of optimism and hope. A "you can do it" when things are tough.

—Richard M. DeVos

79

SPREADING HER WINGS

The idea of winged envelopes flying through the grass was based on an illustration Susanna drew for her husband when they were living apart, in two separate countries. She then saw a blog post by Madelyn Mulvaney and became inspired to write encouraging messages onto the envelopes. "I thought they would look beautiful moving through tall grass in a field," says Susanna. She posted the image on her blog, and began receiving requests from fellow artists who wanted to place the thought-provoking art pieces around their own communities. Susanna poured herself into crafting a new set of one-of-a-kind envelopes, each featuring a hand-written message of positivity. In return, she asked that each participant send her a story chronicling the placement of the messengers or photographs of the pieces in their new environments. And with that, the winged messenger project was born.

Now Susanna creates her winged messengers in her art room—emblazoned with inspirational messages like "your opinion matters" and "you're a work of art"—to send to participants spanning the globe. "If I go a period of time without creating, it feels as though I am missing something deep in my being," she says. "I get antsy, like I'm not doing what I should be doing, what I want to be doing. There's a sense of fulfillment when I work on my artwork, whether the piece is turning out the way I want it to or not, simply because I am creating."

WHEN THE GOING GETS TOUGH

SAYS SUSANNA GORDON: "WHEN THE GOING GETS TOUGH, THE TOUGH ALLOWS HERSELF A MOMENT OF ANGST AND SELF-PITY. THEN MAKES A PLAN AND MOVES ON."

IN SUSANNA'S OWN WORDS:
GIVE IT AWAY

I love the notion of art that's made to give away to others. It benefits the artist as well as the recipient, and it encourages creativity. My challenge for you is to make one piece of artwork today—it can be something as simple as a sketch on a piece of paper or as elaborate as a finished painting, as long as it's a work you've crafted by hand—and then give it to someone without asking for anything in return.

FREE ART

There is something liberating about creating a piece of artwork and leaving it for a stranger to find to keep for free. For me, it's a way of returning something creative back into the world that inspires me. I like to imagine that the messages on my pieces will also resonate with whoever finds it and decides to keep it, or perhaps that person will pass it on to someone in his or her life.

COLLABORATE

Combine your efforts with the efforts of other like-minded people, and you'll be able to achieve things that are greater than what any one person could accomplish alone. The power of collaboration is what has truly allowed my winged messengers to take flight. What started as my own simple, little art project turned into something much bigger, and much better, with the help of strangers around the world.

USE YOUR KNOWLEDGE

Actively use your technical skills—even those that aren't art-related—to make a impact. At the end of the literacy program I volunteered with, a local book publisher bound each student's images and story into a hardcover book free of charge. I was so moved by this act of generosity, and I know that those children will treasure those one-of-a-kind books for many years.

It's not only the messages contained on the envelopes but also the artistry that exudes from each winged messenger that make each piece have maximum impact on those who view them.

EXPRESSING HERSELF

The process of creating—letting your mind wander and exploring the possibilities that exist in life—allows you to tap into parts of yourself that are unreachable otherwise. Says Susanna: "Art has always been a way to express how I'm feeling and what I'm thinking about at that moment of my life. I want to visually express those ideas to others, but most often art-making has been a way for me to figure out how I feel about something." Coping with painful emotions like grief and anger is never easy, but when you give yourself room to openly express what you're going through in your art, you take an active approach to dealing with your feelings.

The death of Susanna's father when she was only 21 left her devastated. She wanted to grieve the loss of the man who played such an important part in her life, but she found herself unable—until she discovered a way to commemorate him through her art. Along with a fellow blogger, Stephanie Hilvitz, she co-hosted an online, Dia de los Muertos-themed event called "Dia de Bloglandia," which invited participants to celebrate their loved ones by posting stories and photographs of handmade altars designed to honor the deceased. Says Susanna: "The most powerful part was the stories that were told about the dead; some of them were funny; some of them were sad; all of them were full of love."

A THOUSAND WORDS

Visual media like photography and painting bring storytelling to its most basic form, and make sharing personal narratives accessible to everyone. Volunteering at a literacy program for children, created by two special teachers at the school, was an opportunity for Susanna to harness the power of art as a universal language, and to use it to change young lives. The participants in her class ranged in age from six to eight years old, and all had struggled with traditional techniques for learning to read. But when art became part of the equation, the students found a new way to express themselves.

Using donated cameras, the children first documented their lives through photography—taking snapshots of their family, friends, and surroundings—and then crafted stories to accompany the images. It didn't matter if the grammar was correct or if the spelling was perfect. That would come later. What mattered was that the students were reading and writing. Says Susanna: "These students had repeatedly failed their reading and writing assessments, and yet they 'got it.' They understood that art could be a way to visually express what someone was feeling inside or trying to say."

Susanna has taken a simple idea of sharing beauty and with the help of the arts community, turned it into a unique phenomenon. "Each of us can use our creative voice to make a difference in this world," she says. "It's just a matter of doing it."

CONNECT YOUR COMMUNITY

Schools are cutting back on funding for arts programs, independent galleries are closing, and non-profit art centers are struggling, and it's all happening in our own communities. Find a local cause that speaks to you, and get involved. You'll not only help an organization that's in need, but you'll also fuel creative connections in your neighborhood.

WINGED MESSENGERS

Before one of Susanna's charming winged envelopes can inspire someone else, she has to settle into her studio, roll up her sleeves, and make it. Beginning with a blank piece of paper, she layers paint, pastels, and messages of positivity to create each one-of-a-kind winged messenger before sending it off to one of her eager participants. This project will teach you how to craft your own winged messengers using Susanna's original techniques, but it's up to you to decide what words to share and who the lucky recipient of the finished piece will be.

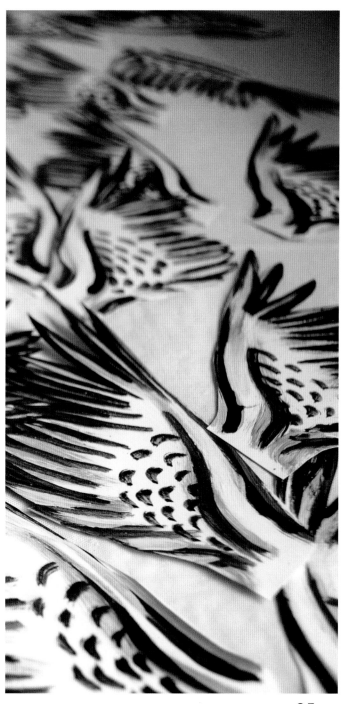

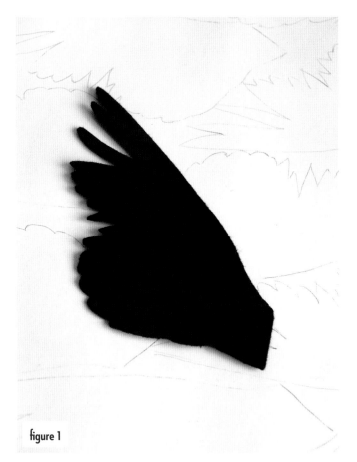

figure 1

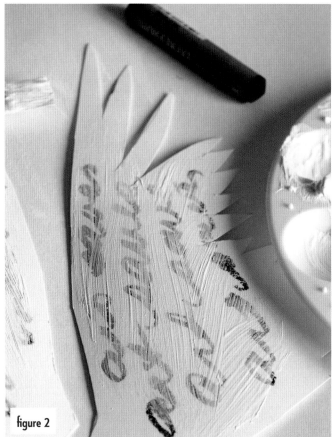

figure 2

figure 3

figure 4

figure 5

MATERIALS:

- thick, uncoated paper or cardstock
- felt
- black pastel
- artist's acrylic paints (black, white, and yellow)
- paintbrushes
- glue

INSTRUCTIONS:

1. Create a wing template from the felt, and use it to trace a wing onto thick paper or cardstock. Flip the template over, and use it to trace a second wing. You will need two wings for each envelope—one left-facing wing and one right-facing wing (figure 1).

2. Using black pastel, write messages onto each of the wings. Mix together the yellow and white acrylic paints to achieve a pale yellow hue, and then apply a thin coat of paint over the top of each wing. Allow to dry thoroughly (figure 2).

3. Add feathers and accent lines to the wings using a thin paintbrush and black acrylic paint (figure 3).

4. Once dry, apply additional accents with white and yellow acrylic paints (figure 4).

5. Cut a rectangle out of the same paper as the wings to create the envelope. Following the same steps used to embellish the wings, add words to the face of the envelope with black pastel and apply a layer of pale yellow acrylic paint over the top (figure 5).

6. Using black acrylic paint, add a line to represent the flap on the envelope and a border around the outer edge, as well as the message (figure 6). Affix the wings onto the back side of the envelope and allow them to dry completely. When finished, the project measures approximately 15" x 8" (38cm x 20cm).

figure 6

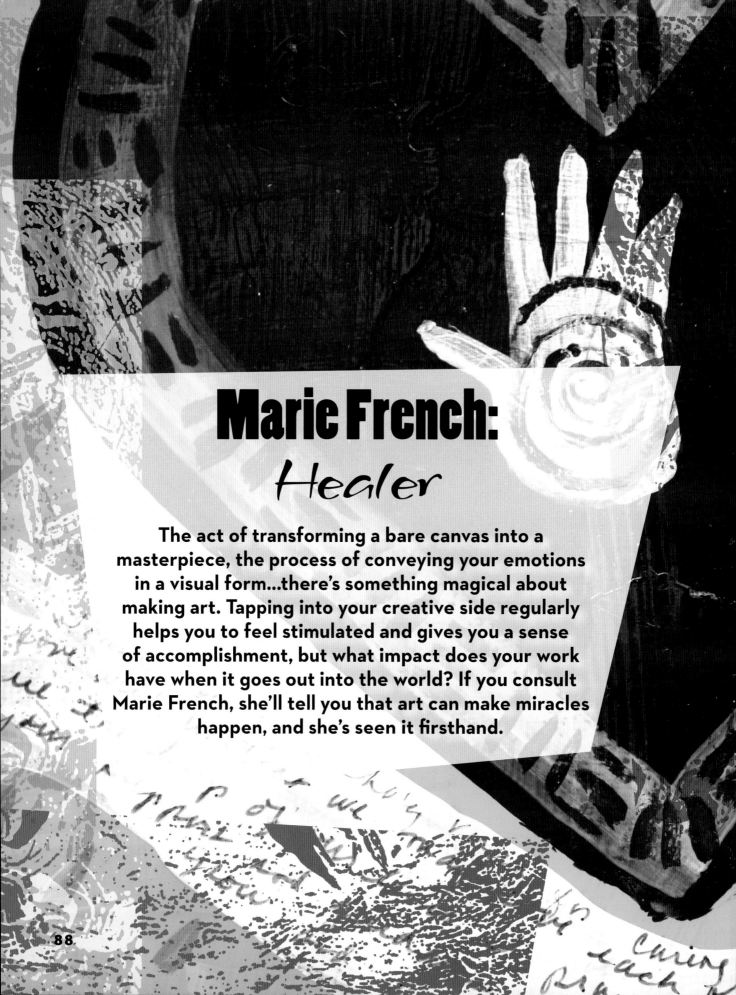

Marie French:

Healer

The act of transforming a bare canvas into a masterpiece, the process of conveying your emotions in a visual form...there's something magical about making art. Tapping into your creative side regularly helps you to feel stimulated and gives you a sense of accomplishment, but what impact does your work have when it goes out into the world? If you consult Marie French, she'll tell you that art can make miracles happen, and she's seen it firsthand.

INSPIRED LESSONS

Don't over-think it. Art is about jumping in and getting your hands dirty, not analyzing every motion. Marie is the most productive when she's able to "move [her] brain out of the way" and let her intuition take over. She spends time repeating basic techniques over and over again so that she can execute her go-to skills without having to put much thought into them.

Get practical. Why spend all of your money on commercially-produced items when you can use your talents to re-create many of them yourself? Marie started sewing her own clothing while in her teens and still alters all of her garments today, in addition to making many of her own home décor pieces.

Mix it up. Your culture, your community, your upbringing, your interests...all of the elements that shape who you are as a person also serve to define your art. Approach your distinct facets with a playful attitude, and see what happens when you mix them in unexpected ways. Marie's art combines sacred imagery from many different cultures and fuses it together with the spirit of the southwest in a way that's all her own.

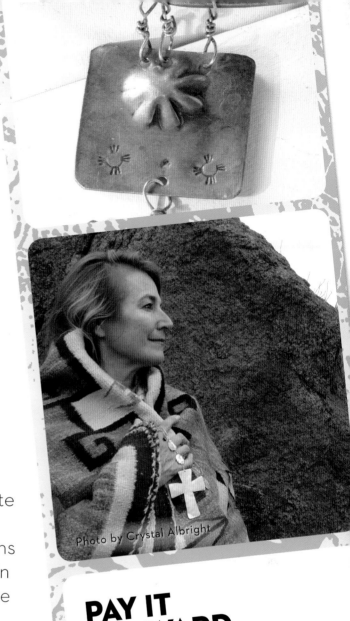

Photo by Crystal Albright

PAY IT FORWARD

Every individual matters. Every individual has a role to play. Every individual makes a difference.

— Jane Goodall

89

Photo by Crystal Albright

MIRACLES & MASTERPIECES

Sharing your art with others and seeing the ways that it affects their lives can give you a new perspective on your art, and provide you with a fresh outlook on the power of creativity. Marie has become quite well-known for her art jewelry but for much of her life as an artist, Marie has also been making ex-votos, prayer vessels, and miracle paintings—pieces infused with wishes and warm thoughts for the recipients. Says Marie: "If my art helps someone, if it gives them comfort, if it uplifts, well then I feel I am an artist."

Her realization of the therapeutic qualities of art began when a woman contacted Marie to commission a custom ex-voto. "She asked me to paint her an ex-voto that was centered around her wish for a baby," says Marie. "She set it on her alter, meditated on it, and in six months she was pregnant, even though she had been told that she couldn't conceive. It was miraculous." And that's not the only miracle that she's seen. Marie has sent other custom pieces to people fighting cancer and mothers of premature babies, with amazing results. "I think the art has helped them to stay focused on the positive, and that's when the healing happens," she says.

IN MARIE'S OWN WORDS: CREATE A MIRACLE

If you know someone who is battling an illness or dealing with a difficult period in their life, take the time to make a piece of art for them. Don't just pull something from your stash of completed pieces...make something new that's designed with that person in mind and fuse positivity into whatever you make.

TRANSFORMATIONS

Just as a collage is made of many layers of paper and paint, it is the complex layering of experiences that defines who you are, and in turn influences the art you make. Like the dust devils that swirl through her native west Texas, Marie picks up bits and pieces from her travels and mixes them into her artwork. By combining her influences, which include Native American and South American art, she has created a cohesive body of work that is a reflection of her life.

Making art gives you an outlet for your energy and emotions, and it uplifts the spirits of whoever you share it with. The transformations that Marie has witnessed through art have been nothing short of miraculous, but it's her ability to infuse her positive energy and well-wishes into the pieces she creates that is truly spectacular. Says Marie: "Each step you take, even the tiny ones, helps to shape the world for the better."

Photo by Crystal Albright

MAKE YOUR MARK

Be true to yourself and let your unique signature shine through in all that you do, instead of trying to mirror what other people have already done. Through your deeds and your art, leave a legacy that will live on into the future.

Susan Tuttle:
Giver

In one scene, you are a child. In another, you are an adult. In one scene, you are at the pinnacle of health. In another, accidents and other devastations dominate your life. In her darkest hour, Susan found herself as a young woman involved in a serious car accident. She not only survived, she emerged with an unprecedented clarity and new outlook on life...an outlook that has aided Susan in the way she approaches her journey as a photographer, digital artist, blogger, musician, and mother.

INSPIRED LESSONS

Forge ahead. No matter who you are, it's likely that there will be critics in your life. Rather than allowing their negativity to immobilize you, use it to motivate you to forge ahead. This is a lesson Susan learned when pursuing her passion for music, where she used the deafening negativity as a motivator to never give up, to move forward, and best of all, to prove the naysayers wrong.

Complete the experience. It's exciting to discover new art techniques and create new projects in the studio. Sometimes, it may feel like such groundbreaking work needs to be covered up and guarded, lest others infringe on your discoveries. Susan has learned that the opposite is true. It's only when you share with others that your work gains meaning, and you open yourself up to continued discovery.

Be vulnerable. The great thing about art is that it can provide a safe and therapeutic outlet for dealing with difficult or painful emotions. Susan has learned that art aids you by allowing expressions of your deepest emotions to be made through it. Art also gains greater value and significance when you dare to include vulnerability in its construction.

PAY IT FORWARD

You cannot hold on to anything good. You must be continually giving—and getting. You cannot hold on to your seed. You must sow it—and reap anew. You cannot hold on to riches. You must use them and get other riches in return.

—Robert Collier

IN SUSAN'S OWN WORDS:
TEACH YOUR CRAFT

I've been able to impart my skills for photo manipulation and digital art through online workshops and two technique-based art books, but making an impact doesn't necessarily take something of this scale. You can teach via tutorials on your blog, volunteer to teach your craft at a local school, or instruct at a local art center or through adult education. It could even be as simple as getting together with art friends for an evening and inviting everyone to present a project in an area of their artistic specialty.

SHARE WITH YOUR COMMUNITY

Find ways to share your art with those around you. Art is about creating connections with others, and by openly displaying our art forms, we invite people to take an active role in the artistic process. I play the flute for my daughter's ballet class as well as art and charity events throughout the year.

CREATING RIPPLES

Sharing both favorite and new techniques with fellow artists has become a passion for Susan. She views this sharing as her ability to give a gift of creativity to people with similar interests around the world—a gift that leaves her feeling just as inspired as the recipients. "When I discover an exciting technique, I have a desire to share it with someone else who is interested, so that they may be able to tap into something that can enhance their art-making, take them in a new direction, spark an idea, maybe even make a real difference in their life," she says.

Susan believes that by simply sharing what we know, we can each be a force of change in the lives of others. "One small stone cast into a body of water will send out multiple circles of vibration that can go on without limit, affecting change in so many ways, mostly unseen and unbeknownst to us." Each time she encourages someone to express their artistic voice, Susan is creating a ripple of inspiration and confidence that has the potential to radiate into the world.

STRENGTH THROUGH MUSIC

Prior to her acclaimed work as a digital and mixed-media artist, Susan basked in the joy of her first creative love: music. The flute is what she learned to play early in her life. And as her musical journey took her from Rutgers University-Mason Gross School of the Arts to the Boston Conservatory, the pressure placed upon her by instructors and peers began to put a strain on her love for music. "To this day, when I play my flute, I can still faintly hear the criticisms, constant reminders about this technique and that, and even remember feelings of humiliation," says Susan.

Instead of allowing the naysayers to stifle her love for music, Susan used the criticisms to strengthen her grit and fortitude to move forward. "In looking back at my life experiences, in particular those times that I was put down, knocked down, or told I couldn't do something, I always found a way to rise to the occasion and prove people wrong," she says.

SURVIVOR SPIRIT

In 1996, in her early twenties, Susan was in a serious and life-changing car accident and emerged from it with a fresh outlook on life, more observant of the world around her. During her recovery, she discovered the visually-artistic side of herself—a side that viewed the world in an entirely new way. "I began to look at my surroundings differently, noticing fine details, textures, and subtle variations in color," she says. "That is when I picked up a piece of drawing charcoal for the first time and began to make sketches of objects, people, and landscapes around me. Later on in life, exploring these art forms saved me as I struggled through multiple miscarriages. The world of visuals arts provided a safe haven in which I could work through my problems and connect with joy during a painful time."

Susan infuses all that she creates, all that she shares, with her story of survivor spirit and ultimately, her faith in humanity. "Share what you know and give of your gifts," says Susan. "When you share of yourself in this way, it will ring true for someone else and has the potential to 'save,' heal, and enable others to move toward becoming their best selves."

WHEN THE GOING GETS TOUGH

SAYS SUSAN TUTTLE: "WHEN THE GOING GETS TOUGH, THE TOUGH NEVER GIVE UP, BUT THEY ALSO KNOW WHEN IT IS TIME TO LET GO AND LET THINGS UNFOLD AS THEY WERE MEANT TO."

TELL YOUR STORY

Your story is unique and has value. Telling it will benefit others. Whether you blog about it, write an article, give an interview, or speak to a classroom, relate your personal story of how the arts have made a difference in your life.

THE GIFT

Come along with Susan as she instructs us how to use Adobe Photoshop to create other worlds—digital montages that have a seamless and surreal quality through masterful manipulation. NOTE: The instructions below assume basic knowledge of Adobe Photoshop CS or Photoshop Elements. A good resource for those who need to acquire basic knowledge may find it in Susan's Book, *Digital Expressions* (North Light Books, 2010).

INSTRUCTIONS:

1. Create an environment by making a composite of multiple images, placing each image on a new layer. Apply an Overlay blending mode to one of the layers to equalize tonal values and blend the hues. TIP: Use the Eraser Tool to erase any unwanted portions of the imagery and promote blending. For the best effect, apply a Soft Brush setting with a reduced opacity level (figure 1, figure 2).

2. Use the Lasso Tool to select a child figure from an old photograph and drag it into the environment you created with the Move Tool.

3. Remove any unwanted pixels with the Eraser Tool, and then colorize the image by using the Paintbrush Tool (figure 3). TIP: Build up color slowly. Try using a soft brush from the Default brush menu, set to a low opacity.

4. Follow the same technique that was used to incorporate the figure of the child to add butterflies. Apply a Motion Blur to the butterflies using the Blur Filter (figure 4).

5. With the Move Tool, click and drag a texture photo to your piece, resizing as necessary.

6. Apply an Overlay blending mode to the texture layer and reduce the opacity level to 27 percent. Move this layer behind the layers of the figure and butterflies by selecting Layer>Arrange on the menu (figure 5).

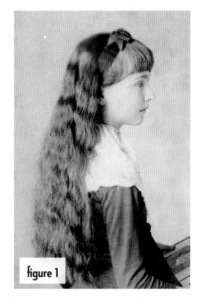

figure 1

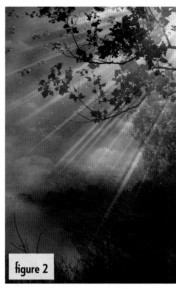

figure 2

figure 3

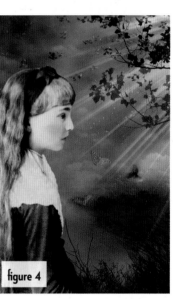

figure 4

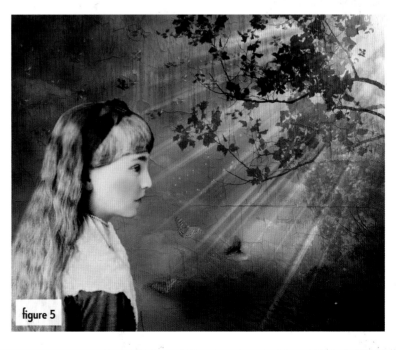

figure 5

Lisa Engelbrecht:
Letterista

Investing the energy it takes to master a technique, and then having the ambition and strength to toss the fundamentals aside and develop your own set of rules, is a sure-fire way to become a trailblazer in the arts community. Lisa Engelbrecht spent years undergoing professional training in the lettering arts, and then broke from tradition to incorporate elements cultivated from her passion for graffiti into classical calligraphy. Now she gives back to the artists that provided her with so much inspiration, working with taggers to help them pursue careers in the lettering arts through a graffiti diversion program she started in her area.

INSPIRED LESSONS

Break the rules. If you want to be an innovator, don't be afraid to break a few rules. Lisa has rejected the established fundamentals of calligraphy to create entirely new ways of conveying her messages through lettering arts. She isn't intimidated by experimenting with new materials or playing with unexpected color combinations.

Try it all. When it comes to your art, never stop learning and never stop trying new things. That's the legacy that Lisa hopes to leave, one of never giving up on making new discoveries. She wants to be remembered as the person who tried it all.

Get a reaction. When people see and react to your art, it's not the type of response that's important, but the fact that you are able to elicit a reaction at all. If Lisa is able to reach out to her audience through her art and inform, engage, or even enrage them, then she views her work as a success.

Photos by Shaun McGrath

PAY IT FORWARD

The only people for me are the mad ones, the ones who are mad to live, mad to talk, mad to be saved, desirous of everything at the same time, the ones who never yawn or say a commonplace thing, but burn, burn, burn, like fabulous yellow roman candles exploding like spiders across the stars and in the middle you see the blue centerlight pop and everybody goes "awww!"

—Jack Kerouac

IN LISA'S OWN WORDS: SHARE YOUR STASH

Creative people tend to accumulate the most incredible collections of "junk" and assorted supplies, and we often end up with more than we can use. Invite a group of your artist friends over and share your stash with them. Watching other imaginative individuals make use of your materials will have you seeing your supplies differently.

REBEL WITH A QUILL

Art is accepting of everyone, whether you choose to follow tradition or set out on your own path. It's in that spirit that Lisa started a graffiti diversion program in her community, one that puts the focus on the talents of the artists behind the graffiti and encourages them to seek out opportunities in professional lettering. One of her future goals through this program is a collaborative mural project that features the artists she's involved with. "I just need to learn to use the spray can as well as my graffiti friends," says Lisa.

Lisa's also seen how art can empower even younger pupils, having taught bookmaking at an after-school program called Thank Goodness It's Today. "The kids were so into it, even though they only spoke Spanish and I only spoke English—it didn't matter because art has its own language," she says. "When the class ended, the students lined up to hand me the books they made. I said, 'no, es para ti,' which I think means 'it's for you,' and their eyes just lit up."

When you put your energy into giving back to your community, your community gives back to you. Says Lisa: "To have the joy of seeing your unique gifts reflected in the faces of your students, to be able to witness life-altering transformations taking place right before your eyes...it's the teacher who is really blessed."

BEING SPONTANEOUS

At times, it can be difficult to remind yourself to be spontaneous when you have to maintain a balance between the duties and responsibilities in your life. But for Lisa, finding ways to encourage her free-spirited ways is an integral part of being successful. "My nature is to be adventurous and a bit of a provocateur, and it's essential for me to be true to who I am," says Lisa. "It's the simple actions, like some impromptu doodling or painting on blank fabric, that make all the difference on those days when I feel like I'm stuck in a rut."

Another way to shake up your creative routine is to incorporate unconventional materials into your repertoire. Lisa's rebellious streak has led her to be innovative with her writing implements, which range from conventional calligraphy pens and basic ballpoint pens to handmade varieties crafted from soda cans and dental supplies. Changing up her tools regularly forces Lisa to constantly hone and refine her skills, and prevents her from getting too comfortable in her art-making process.

Embracing your spontaneity means never having to take "no" for an answer. "In this life, anything is possible. Just tell yourself, 'I can do that,' then act on it, and the world will be a better place for it," says Lisa.

CREATE FOR GOOD

The next time you wake up feeling full of inspiration, designate that day as a "create for good" day and donate all of the art you make to your favorite charity. It'll make you feel great.

MAKE A SIGN

Bring out your inner spontaneity by crafting a sign for your studio or any other room of your home. Simple messages like "Jump!" or "Be fearless" will invite you to take some chances from time to time, both in the art you make and the life you lead.

Trust

Grace

This, too, shall pass

CALLIGRAPHIC WALL HANGINGS

These colorful signs, which are adorned with inspiring words and phrases, embody Lisa's whimsical and vibrant style. By letting her own individuality shine through, and by finding beauty in the little imperfections that occur when she creates, she's able to transform simple scraps of wood into one-of-a-kind works with personal meaning.

MATERIALS:

- smooth wood (scrap lumber or Masonite pieces)
- awl
- white gesso
- foam brush
- India inks (Dr. Ph. Martin's Bombay)
- black waterproof ink (like Sumi ink)
- colored pencils
- pointed paintbrush (a specialized brush with a tapered tip available at art supply or calligraphy stores) NOTE: With practice and experimentation, you can achieve elegant strokes using almost any writing instrument that you like, such as a calligraphy pen or traditional paintbrush.
- tie wire (thin, galvanized wire available at home improvement stores)
- wire cutters

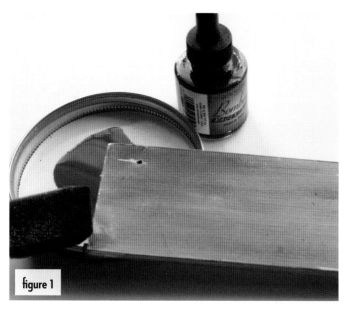

figure 1

figure 2

figure 3

figure 4

figure 5

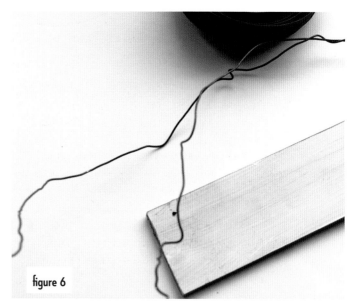

figure 6

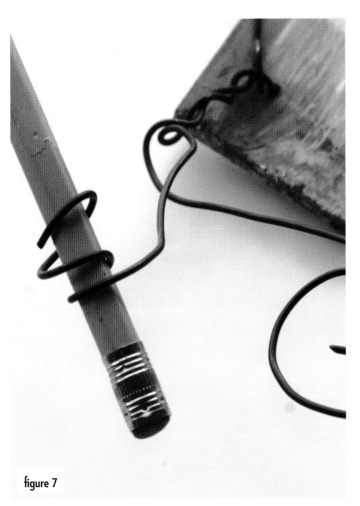

figure 7

figure 8

INSTRUCTIONS:

1. Cut smooth wood or masonite into pieces that are approximately 10" x 2½" (25cm x 6.35cm). The lumber department in home improvement stores is where you can get wood or masonite cut to size. Use an awl to punch small hanging holes in the top corners of each piece.

2. Completely cover each piece with white gesso using a foam brush. This coat does not need to be overly precise, as it will be covered by India ink. Allow to dry thoroughly.

3. Dilute India ink colors and use a foam brush to apply a layer to the surface and edges of the wood piece and let dry (figure 1). Once dry, you can add other colors of diluted India ink as desired (figure 2).

4. Next, apply additional strokes of white gesso to the center portion of the piece. Let dry completely (figure 3).

5. Using a pointed paintbrush and black waterproof ink, add words or quotations to the piece in a rustic handwriting script. If desired, thicken the down strokes with a second layer of ink. Allow to dry (figure 4).

6. Add color between the letters by scribbling with different shades of colored pencils (figure 5).

7. Use wire cutters to cut a 24-inch (61cm) piece of tie wire and feed it through one of the holes and then twist along the way and secure at the other hole (figure 6). Twist excess wire around a pencil to form curlicues (figure 7).

8. For a different effect, try using a small branch in conjunction with the tie wire to create a hanger (figure 8).

Jette Clover:
Constant Creator

Being the best at what you do takes practice...just ask Jette Clover. Fueled by a passion for mixed-media, she took on an ambitious experiment that challenged her to complete a piece of artwork every day for an entire year, and succeeded. Her secret? She made a commitment to set aside at least 10 minutes each day for her art, and made creativity a part of her daily routine.

INSPIRED LESSONS

Wabi-Sabi. No one's perfect, and that's the beauty of life. Your imperfections, as well as the imperfections that exist in your art, are special and unique to you. Just like the worn, rusty, scratched, and broken treasures that Jette seeks out at flea markets, it's the things that have a little "wabi-sabi" that are the most extraordinary.

Get in the habit. If you want to find a way to fit art into your life, then make a habit of getting creative. Jette's journey began when she pushed herself to make a miniature art quilt every day for a month, and it led her to a year-long collage campaign shortly thereafter.

Make it easy. Don't set yourself up to fail. One of the reasons that Jette was able to succeed in her daily art challenges was that she established realistic goals for herself. Instead of trying to create large, mixed-media masterpieces every day, she limited the size of her canvas and elected to work in a single medium.

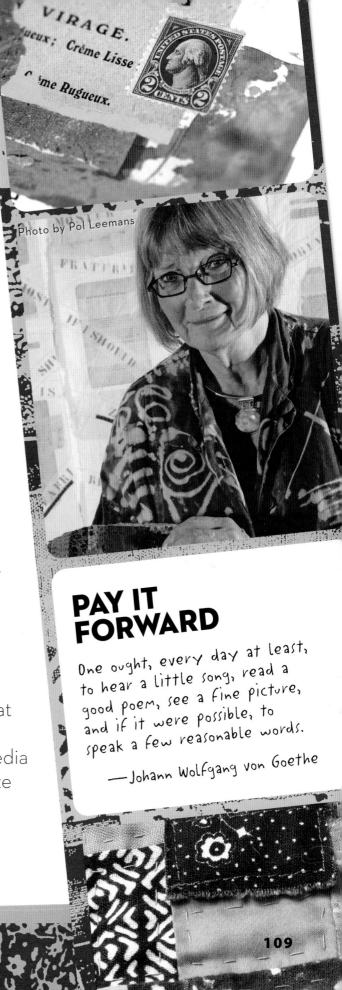

Photo by Pol Leemans

PAY IT FORWARD

One ought, every day at least, to hear a little song, read a good poem, see a fine picture, and if it were possible, to speak a few reasonable words.

—Johann Wolfgang von Goethe

CREATING EVERY DAY

Making the decision to get serious about creating art is one half of the battle, and staying true to that decision is the other. Jette's resolution to spend a month making art quilts wasn't about exploring new techniques, trying out materials, or even creating a chronicle of her day-to-day experiences, but was designed to test her self-discipline. Says Jette: "I wanted my artwork to come first—before the laundry, before checking e-mails, and before thinking about what to make for dinner."

Jette succeeded in her goal of quilting for 30 days straight, but sewing that final quilt was bittersweet. "It was with a certain feeling of loss that I finished my month of quilts, but when the new year approached, I took that as my opportunity to make a new promise to myself," she says. "That's when I decided to make a collage every single day for a year." Limiting herself to the space of an index card and using only paper that was already in her collection, she began tearing, pasting, and layering her collection of small-scale collages—a strategy that helped to define her success.

IN JETTE'S OWN WORDS: HELP OTHERS DO WHAT THEY LOVE

Once you've made art a regular part of your life, help people you care about make a habit of pursuing their interests. Prepare a meal for them, watch their kids for an evening, or simply give them encouragement, and watch their passion blossom.

AN OPEN DIALOGUE

Every time Jette starts a new project, she views it as a two-way conversation between herself and the recycled objects that she collects and incorporates into her art. "Making art to me is having a dialogue with materials—and 'found' materials with a previous life and holes and stains have stories to tell," she says. The quilted dolls shown here are an example of this conversation in action, as Jette digs deep into her collection of vintage fabric scraps to create each one. Working with recycled materials is like a history lesson; it brings you in contact with the past and lends an unmistakable depth to your artwork.

Starting with a piece that's already endured a lifetime of scratches, scuffs, and tarnish also takes some of the stress out of creating. Says Jette: "We all know how intimidating it can be to start on a clean, white piece of paper or fabric. Reused materials are imperfect, and they give you something to relate to." With focus, tenacity, and an impressive stack of original collages at her side, Jette continues to live out her artistic ambitions, one day at a time.

Photo by Pol Leemans

REDUCE & REUSE

Using recycled materials in your art not only adds character to your work, but also helps to make the world a greener place. Instead of buying commercial embellishments and patterned paper, take a trip to your local flea market and stock up on buttons, metal charms, sheet music, and other assorted vintage materials.

111

Melody Ross:
Brave Girl

Courage is something we all want to claim as a personal asset. But where does courage rest when in the blink of an eye, all hope seems lost? That was the question Melody had to grapple with after truly "having it all," with a multi-million dollar business, a beautiful home, and flourishing family. In the blink of an eye, she lost it all after her husband suffered a traumatic brain injury. As he fought to recover over the course of five years, she held on to the hope of a new day. Through this process, Melody found solace in reconnecting with her artistic roots, which is what ultimately saved her and helped her understand the true meaning of bravery.

INSPIRED LESSONS

Do it anyway. You have dreams. You have aspirations. You also have critics, fear, and doubt. In the face of it all, Melody has learned that even in the midst of uncertainty, you need to move forward with your dreams anyway. Even if someone thinks you shouldn't, do it anyway. Even if someone might do it better, do it anyway. Don't let anything stop you from pursuing your dreams.

Protect your soul. Not every person, place, or thing can or deserves to be part of your inner circle. Melody has learned that your inner circle needs to be filled with those who you trust most, and who nourish your soul the most...a place that can build you up rather than stress you out.

What's done is done. We all have regret, right? We say to ourselves: "This could have been done better," or "That could have been avoided." Rather than wasting time regretting, Melody has learned the importance of accepting the past, mistakes and all, and moving forward. After all, what's done is done.

PAY IT FORWARD

Never forget that life can only be nobly inspired and rightly lived if you take it bravely and gallantly, as a splendid adventure in which you are setting out into an unknown country, to meet many a joy, to find many a comrade, to win and lose many a battle.

—Annie Besant

THE CLIMB, THE FALL, THE COMEBACK

On her climb to the top of the corporate ladder, Melody Ross enjoyed all of the accolades and rewards as head of a multi-million dollar business. The frantic pace of her corporate life did take a toll, though, as she felt the squeeze to push out all of the creative activities that she had so loved all her life. As she donned her power suit and high heels every day, her once-cherished art supplies became relegated to storage.

Then one day, everything changed.

Melody's husband, Marq, was involved in an accident that resulted in a severe brain injury. For five years, Marq struggled to climb back from the "dark place" that the trauma had taken him. During the recovery, they lost their home, their business, and the life that they had built. To cope with this devastation, Melody found herself rediscovering collage, which became a therapeutic medium for dealing with her anguish, and which allowed her to find a way to come back. "Each little piece of paper and fabric felt like a reclaimed piece of my life, and I felt power in taking what my life used to be and making it into something different," says Melody. "It helped me to make sense of things."

FOUND AGAIN

After her husband's recovery, Melody vowed that she would move forward in her career by sharing all of the encouragement and joy that she could, especially with people who were having difficulty navigating their way out of the darkness that life sometimes offers. She created a curriculum based on her experiences, including the integration of the most important ingredient to finding oneself: art.

WHEN THE GOING GETS TOUGH

SAYS MELODY ROSS: "WHEN THE GOING GETS TOUGH, THE TOUGH DO THE VERY BEST WITH WHATEVER THEY HAVE BEEN GIVEN. THEY DO IT AS JOYFULLY AS POSSIBLE (AFTER THEY THROW A BIG FIT IF THEY NEED TO) WITH THE BELIEF THAT EVERYTHING WILL ALWAYS WORK OUT EXACTLY AS IT'S SUPPOSED TO, AND THAT EVERYTHING THAT HAPPENS IN OUR LIVES MAKES US WHO WE ARE MEANT TO BE."

With the help of her oldest sister, Kathy, Melody now holds Brave Girl Art + Life Retreats throughout the year, inviting women from around the world to gather in McCall, Idaho, for a special time of self-reflection and creative exploration. "Watching the way women find their souls' songs through creating is a miracle to behold, every single time," says Melody. "I see them walk in on the first day, burdened by life and heavy with sorrows and concerns…then after immersing themselves in art, completely filled with light and unburdened, ready to take on the world."

In this new season of life, Melody enjoys spending time in her studio where with her beloved art supplies to create bright and colorful works that help her keep focused on the beauty of life.

IN MELODY'S OWN WORDS: FIND STRENGTH

Courage comes in many forms, from accepting your own flaws to providing support to those in need, and learning how to summon that strength is one of the greatest gifts you can give to yourself and those around you.

READ THE SIGNS

Though we don't wear signs around our necks that tell the world what each of us are going through, we all offer glimpses into our struggles in the way that we carry ourselves. Take the time to read the signs that others give you about the challenges they face in their lives, and treat them with compassion and understanding. A little bit of caring goes a long way.

115

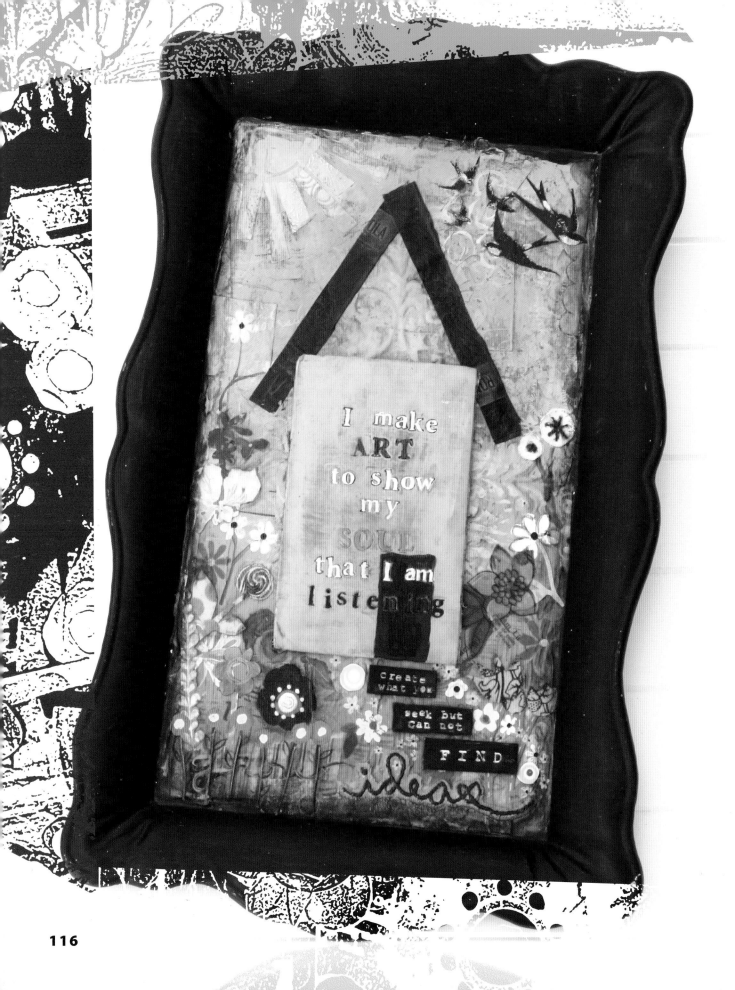

CREATE WHAT YOU SEEK

With the help of metal stamps that Melody designed for GCD Studios, she shows how to create a unique collage using a book cover, a metal tray, and lots of colorful papers and fabrics. By using the metal stamps to integrate words and texts that are special to you, the piece becomes that much more meaningful.

MATERIALS:

- old book cover
- spray bottle with water
- metal letter stamps (GCD Studios)
- old metal tray
- acrylic paints and spatula
- Mod Podge
- assorted papers and fabrics
- rubber stamped images
- paintbrushes

INSTRUCTIONS:

1. Tear the cover off of an old hardback book (figure 1).

2. Lightly sketch the words you would like to stamp onto the cover and then spray it with a mist of water (figure 2).

3. Use metal letter stamps with punch handle to start punching desired text onto the book cover (figure 3, figure 4).

4. Gather an old metal tray, 24" x 14" (61cm x 36cm), along with thick acrylic paint and spatula (figure 5).

5. Use spatula to apply thick layers of paint onto the metal tray (figure 6).

6. Use Mod Podge to adhere assorted papers and fabrics onto the painted tray (figure 7).

7. Once dry, paint the adhered fabrics and papers to blend all elements in (figure 8).

8. Cut out clip art or rubber-stamped images and adhere onto the tray (figure 9).

9. Use colorful acrylic paints to paint flowers and other desired icons onto the treated tray (figure 10).

10. Gather and cut chipboard sheets and use metal stamps to punch text and adhere it to the final collage (figure 11).

figure 1

figure 2

figure 3

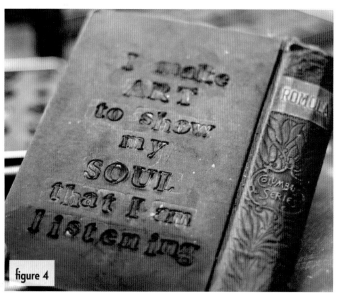

figure 4

figure 5

figure 6

figure 7

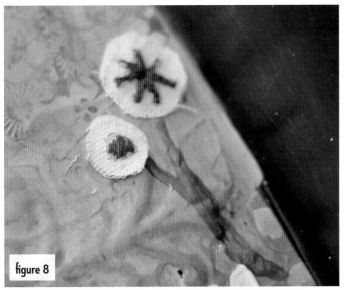

figure 8

figure 9

figure 10

figure 11

Christine Mason Miller:
Optimist

Once you master the ability to see the glass half full, it's not enough to keep that awareness to yourself. Optimists have a special calling to share their outlook with others, thereby empowering them to also accentuate the positive rather than the negative. This is a calling that Christine Mason Miller takes seriously as she works every day to be a role model of focusing on the hills, despite occasional valleys.

INSPIRED LESSONS

Stay positive. Especially when you have worked so hard, and things don't turn out, or when unforeseen mishaps occur, it's tempting to focus on the negative. Hard-working and determined, Christine learned early on that what you focus on is what you get more of. So even in the midst of disappointment, she reminds herself that in order to decrease the bad and increase the good, it's the good you need to focus on.

All of the above. If you're interested in painting, writing, dancing, and dreaming, there's no rule that says you should just choose one from that list. Christine has lived and learned firsthand that it's OK to pursue as many interests as a person may have...and enjoy the blossoms that grow in multiple directions.

Embrace your imperfections. If you want to learn how to do something new, you need to know that your journey through the process of learning will be filled with mistakes and imperfections. Christine has learned that imperfections serve as evidence that sincerity of heart is at play. It's when you let go of trying to be perfect and enjoy the process that magic happens.

Photo by Thea Coughlin

PAY IT FORWARD

No act of kindness, no matter how small, is ever wasted.

—Aesop

BEAUTY

IN CHRISTINE'S OWN WORDS:
SAY "HELLO"

When you're checking out at the grocery store, interacting with a teller at the bank, or being greeted by a waiter, look them in the eyes and say "hello." Ask how they are. This is so simple, but you'd be amazed by how much of a difference this small gesture can make in the lives of others.

FROM DAY ONE

Although her professional focus has transitioned from cards to wall hangings and rubber stamps, paintings, and more, the messages of positivity that shine through all of her creative offerings are constant. "From day one, the mission behind my work as an artist has been to inspire others to follow their dreams and create a meaningful life," says Christine. "I put work, words, and messages in the world that I hope will remind people of all the beauty that exists in every single moment."

The thing about inspiring others is that you don't have to wait until you have a grand gesture to offer. It can be small. Really small. "It doesn't take putting together an entire collection of work for a gallery show to be inspiring. It can be something as simple as taking a first step toward a dream—signing up for a class, buying that first canvas," she says. "Everyone around you will see you taking those steps and likely be inspired to take their own first steps."

DREAM IN ACTION

The whole thing about taking small steps is that over time, they make a huge impact. To create her very first book titled *Ordinary Sparkling Moments*, Christine gathered all the small and beautiful messages that she had been polishing over the years to develop a cohesive narrative in this, her very own self-published book. It is a book where she invites readers to honor the mundane and to find their muse within their everyday, ordinary experiences.

The goal extends beyond the book itself, as Christine is currently involved with what she calls the "100 Books Project"—an experiment in which 100 copies of the book are being deposited in unexpected locations around the world for people to discover. One book at a time, one step at a time as Christine stays true to honoring each step while keeping her eyes on her biggest and most audacious dreams.

WRITE AND SEND LETTERS

Don't let mailing cards, letters, and small packages become a lost art. Sending unexpected mail is a lovely way to make a friend feel special, whether they're half the world away or just down the street. It's a small way to make a large statement of how much you're thinking of them, and how much they mean to you.

LK Ludwig:
Visionary

Without warning and with devastating might, physical impairments can enter your life by way of an accident, illness, or disease. Upon suffering a stroke, lifelong photographer, LK Ludwig's eyesight became damaged. After working through the shock and grief, LK did not allow herself to be debilitated by her visual impairment. Rather, she explored new ways of seeing and continues her journey as a photographer to demonstrate that artistic ambitions can take new shape and form.

INSPIRED LESSONS

Try something new. If you're a photographer, consider taking a class in bookbinding. You'll be surprised to learn that taking a class in a media that you are unfamiliar with can lead to a boost in artistic confidence.

Do not retreat. No matter how devastating or challenging life may feel, know that the creative spirit always finds an outlet, even if it has to overcome obstacles in the process. Rather than giving up or retreating, find ways to adapt, improvise, and embrace the unplanned twists and turns that life affords.

Bring it on. When you are experiencing a creative rut, intuition may tell you to take time off and rest. However, sometimes going counter-intuitive and adding a new project or challenge to your plate may be what you need to get ideas to flow and succeed.

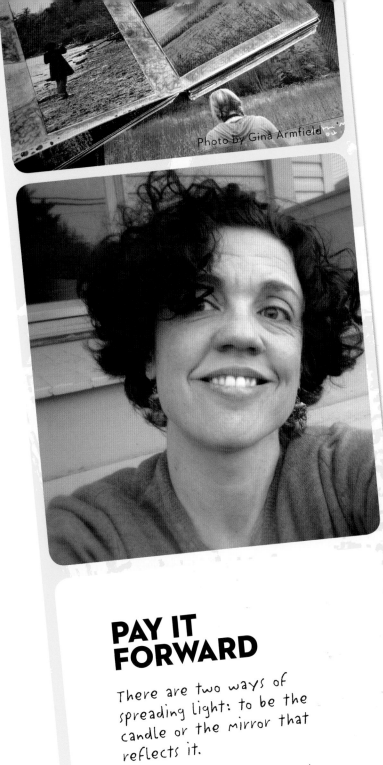

Photo by Gina Armfield

PAY IT FORWARD

There are two ways of spreading light: to be the candle or the mirror that reflects it.

—Edith Wharton

IN LK'S OWN WORDS:
PRACTICE INCLUSION AND COMPASSION

In order to be admitted to the post-baccalaureate program at my university, I needed to complete an interview with the chairperson at the Art Department. I had no portfolio to submit for review, but I had this overwhelming need to make images. I sat down in my interview and was asked to talk about why I wanted to be admitted. The words tumbled out to express my longing, and my heart was laid bare in front of him. When I could calm down enough to make eye contact, the gaze I held was compassionate and understanding without any notes of condescension. He treated me as a fellow artist, despite the fact that I had not yet been admitted to the program or taken a single class. That attitude of inclusion and compassion made all the difference in the world. Honestly, that interview changed my life.

VISION & VOICE

Seven months into her first pregnancy, LK experienced a small stroke that damaged her eyesight, leaving her with blind spots in both eyes and making it nearly impossible for her to focus her dominant left eye. This devastation came after she had worked so hard to find her true voice through photography as she was pursuing her BFA at a local university and finally experiencing success in selling her artwork and gaining acclaim through galleries and various publications. "I had already known that my darkroom time would be limited with a new baby, but being stripped of my primary voice was unexpected," she says.

ART FINDS A WAY

Determined not to let her visual impairment interfere with her passion for photography, LK set about exploring other methods of expressing her artistic side. "I began to research alternative processes like cyanotypes, image transfers, non-digital photo manipulation, and Polaroid film," she says. "I bought different kinds of Polaroid cameras and learned to chemically sensitize paper for cyanotypes, and my husband bought me a good film camera with automatic settings and a day-lab slide printer."

Overcoming an obstacle that had threatened to silence her inner artist, LK found strength to venture into other art forms. "Learning that my artistic voice wasn't limited to my ability to focus a camera, that there would be no more holding that voice back, changed my life, gave me a level of confidence and certainty that I could not have gained any other way," says LK. This self-assurance led her to indulge other interests, including her love for books and paper, which has manifested itself in the form of mixed-media journals.

GIVE POSITIVE FEEDBACK

Being a teacher is more than showing your work to your students and demonstrating techniques. Part of teaching is offering positive feedback and showing off what is best about a student's work. As artists, we are often hard on ourselves and can be hyper-critical. While critique can be seen as a teaching tool, positive feedback can teach in far more powerful ways.

127

THE 100 ASSIGNMENT

The 100 Assignment is a popular art school assignment that challenges photographers to stretch their creativity as they shoot the same object in 100 different ways. Lessons that this assignment teaches celebrate the resilience that each of us have within ourselves, to figure out new ways to solve challenges both in life and in art. LK offers a unique perspective to this 100 Assignment process, with tips on how to translate the photos onto an art journal.

ASSIGNMENT:

1. Choose one subject and photograph it 100 different ways.

2. Complete all photographs in no less than 100 days and no more than one year.

3. Each shot that you take of your selected subject should differ in some sort of way— angle, approach, mood, lighting, time of day, weather, season, content, composition, or color.

4. Try to accomplish the assignment with at least 10 different shooting sessions.

5. Brainstorm a list of possible ideas about how or when to photograph your subject, and write it in your journal.

6. Throughout this process, keep yourself centered on the purpose of seeing your subject in as many ways as possible, using your inner, photographic vision.

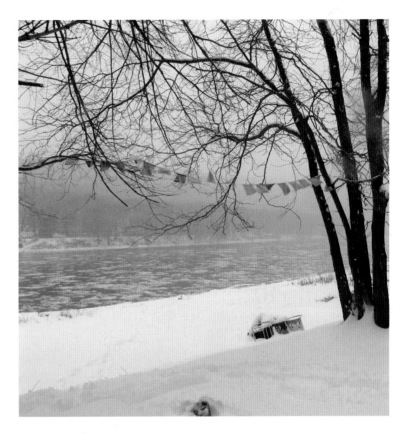

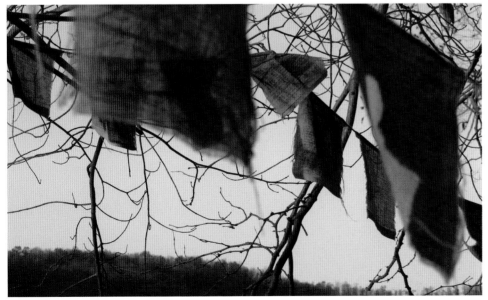

AFTER EACH PHOTO SESSION:

- Review all of your images and choose at least one photograph from each session to print out for your journal.

- Print your photographs, and paste them onto a journal page.

- Write about the messages you were trying to convey with your images, and describe what you want people to see when they look at each photograph.

Drew Emborsky:
Comforter

Comfort comes in many forms, from the beloved blanket that carried you through childhood to the bowl of warm soup that soothes you when you're sick. As "The Crochet Dude" Drew Emborsky has learned, comfort can also come from a crochet hook and a ball of yarn. Stitch by stitch, Drew transforms humble bits of fiber and thread into thoughtful gifts that provide much-needed comfort to the recipients, while giving him the strength to overcome the occasional struggles in his own life.

INSPIRED LESSONS

Everyone can learn. When you are passionate about acquiring a new skill, it doesn't matter what supplies you have or how old you are, because it's fulfilling the desire to learn that's most important. Drew never lets anyone tell him that they "can't learn" to crochet, because he knows that it's all about building their confidence.

Stages of development. Just as there are stages of development in life, you will experience stages of development in your art. Instead of being critical of the different forms his art has taken over the years, Drew appreciates each piece for the joy it gave him at that time, and reflects on how much he has grown since then as an artist.

Absorb knowledge. Though Drew felt that the art teachers he had early on were tearing down his methods of creating art, he later realized that they were helping him to develop his technical skills to enhance his natural abilities. When someone is willing to pass their knowledge on to you, be grateful and absorb all that you can.

PAY IT FORWARD

Give all to love; obey thy heart.

—Ralph Waldo Emerson

131

IN DREW'S OWN WORDS: MAKE AN EXTRA

The next time you make a baby blanket, quilt, pair of socks, or other hand-crafted item, get enough supplies to make two so that you can give one to a local charity. It only takes a small amount of effort to make an extra, but the value of a handmade gift—one that comes from the heart—is immeasurable.

CREATING WITH EMOTION

When you invest your time, energy, and imagination into a project, you're instilling a little piece of yourself into it as well. The common thread that runs throughout Drew's knitted and crocheted designs, which include stylish garments, funky accessories, and inventive home décor items, is the heart that he imbues into everything he makes. Says Drew: "One thing I know for sure is that through the creative process the artist infuses the project with his emotions, his feelings, his intentions and in the end, that is what is felt when others come in contact with his art."

Part of incorporating yourself into your art is being true to your passions, and for Drew that means striving to find beauty in everything. In his eyes, there is no material that's "good" or "bad," and no art form that's "better" or "more important" than any other. "All of it has a place in my world, and I celebrate it all," says Drew. "What is important is that I'm being authentic to what inspires me, drives me, makes me feel happy, and allows me to create what I consider to be beautiful."

CROCHETING COMFORT

The power of art becomes the most apparent when you're faced with adversity, and you're able to find solace through the creative process. For Drew, it was the death of his mother that led to him to discover that crocheting, or any other art form for that matter, can heal even the deepest wounds. He turned to his hooks and his yarn to celebrate her memory and overcome his grief. Says Drew: "It came to me one day that the one activity we had shared together was crochet."

As Drew crocheted his way through his emotions, he found himself with a growing collection of afghan squares. He got involved with Heartmade Blessings (*www.heartmadeblessings. org*), a charity that accepts afghan squares from around the world and transforms them into "comfortghans"—cozy blankets that are distributed to people in hospitals and shelters. Being able to share the warmth of a handmade gift with someone in need is really what art is all about.

LOOK LOCAL

Ask around your community and find organizations that you can donate your handiwork to. Start with churches, hospitals, and shelters, as they are often in need. Don't forget to look into animal shelters—our four-legged friends need comfort too!

133

Jenny Doh:
Active Listener

Listening to others and to oneself takes courage. Because when you listen, you sometimes find that the direction you ought to take with your life needs to shift, even if such a shift is risky. In the midst of enjoying success in the magazine publishing world, Jenny listened to her heart and made the leap to found www.crescendoh.com, a site that facilitates the telling of heartfelt stories about the power of art. This has been one of the most courageous moves she's made, one that she hopes will rally a critical mass within the creative community to increase compassion for those in need.

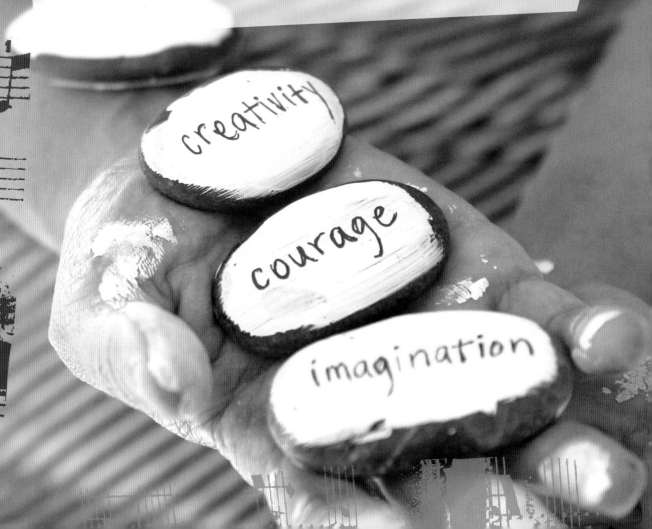

INSPIRED LESSONS

Look outward. When we experience pain, it's easy to fixate on that pain. It is when we stop focusing on ourselves and look outward and find ways to help others that we stop drowning in our own troubles and gain a more balanced perspective. For Jenny, this is the ultimate benefit of cultivating compassion...because through helping others, we help ourselves.

Lead with calm. When faced with a challenge, worrying about all that can go wrong can cause you to panic or become immobilized with fear. Throughout her career, Jenny has learned that no matter how daunting a situation may seem, things will be OK. She is a fervent believer that those who remain calm and focused in the midst of chaos are the ones who lead the way.

Stay seated until the work is done. While feeling the pressure from major deadlines and project demands, you might be tempted to take a break and go on a field trip to find inspiration. For Jenny, that is rarely the case, especially when it comes to writing assignments. She has learned that when deadlines are looming, her first line of defense is to stay seated, disciplined, and get to the work of writing.

PAY IT FORWARD

What you do speaks so loudly I can't hear what you are saying.

—Ralph Waldo Emerson

135

CREATIVE LIFELINE

Even in the scariest and most uncertain of times, Jenny has known that as long as she could create, she would persevere. This lesson was first learned when she boarded the airplane that would take her from her homeland of Korea to the United States at the age of seven. The thing that Jenny held onto for comfort during the flight was her yarn and knitting needles. "Even though I was scared, looking at the yarn made me calm down and somehow understand that with my ability to create something with that yarn, everything would be OK," she says.

Some 20 years later upon becoming a mother, Jenny rediscovered the lesson about the healing power of art. "Motherhood is filled with joys, but also filled with sorrow," says Jenny. "Some days, you just don't know how you're going to make it through and you feel invisible. For me, in the bleakest of moments, I grabbed for my yarn, my rubber stamps, and my sewing machine. These art and crafting tools became my lifeline and gave me hope that my voice and my identity could still be found through the act of creating."

WHEN THE GOING GETS TOUGH

SAYS JENNY DOH: "WHEN THE GOING GETS TOUGH, THE TOUGH HOLD ONTO THEIR VALUES. AND THEY MAKE SURE THAT THEIR BEHAVIORS ARE IN ALIGNMENT."

IN TUNE AND ENGAGED

Though Jenny is known for her minimalist collages, art quilts, and fiber arts, her greatest artistic passion is crafting her words. "My art is in the words I speak and write. And it is through the reactions of people who have been affected for the better by my words that I consider myself a successful artist," she says. A critical element to being a good writer and speaker is actually being an active listener. "If you're only fixated on yourself and not listening, it's hard to say or write anything that will resonate with others."

Part of listening is also listening to yourself. And when you are engaged with this type of active listening, you are able to find deep conviction to take needed action or change direction in life. This is exactly what happened to Jenny as she made the courageous leap from a successful career in magazine publishing into launching a company of her own: *www.crescendoh.com*. "It is a company with a mission to inspire creative passion, authentic community, and focused compassion by highlighting artistic content from imaginative people and websites, showcasing philanthropic organizations, and providing a forum where people can share their personal stories about using art to overcome adversity," says Jenny.

"Life is short. And because it's short, we ought to use our art for good to make the most impactful mark we can. And of course that impact will be strongest when we are in tune and truly listening."

Since childhood, yarn and music have been ever-present companions in Jenny's life, and have helped her to succeed in even the most challenging times.

IN JENNY'S OWN WORDS:
LISTEN

I think so many of the world's problems can be solved when we listen to one another. It takes generosity and discipline to refrain from speaking and to allow someone else to speak. And it's usually the listener in the group who understands what needs to be done and leads the way. And when a plan to lead is based on an authentic assessment that can only be done through listening, great things happen.

LISTEN GLOBALLY AND ACT LOCALLY

Read the news. Read books. Be aware of what's happening in the world. Being aware and listening to different perspectives helps develop compassion and passion for others. As you listen to the world, if something tugs at your heart, do something. Plant a tree. Give food to a person on the street. Donate money to your church or charity. Write a grant. Start a movement.

COLLAGE ON THE ROCKS

Jenny believes that knowing who we are and knowing what we value are requisite to leading a truly fulfilled life. Rocks are one of her favorite elements to work with, because like values, they are solid—with weight and significance. This collage project incorporates the use of embellished rocks that are integrated into a final composition with simple elements and a message that reminds us that no matter the problems of yesterday, today is a new day to make it new.

figure 1

MATERIALS:

- rocks with a smooth, flat surface
- white gesso
- foam brush
- vintage papers
- paintbrush
- Mod Podge (or other adhesive medium)
- book cover from an old hardback book (or other firm substrate)
- fabric scrap
- graphite pencil
- strong-hold adhesive (E-6000)
- hemp yarn
- awl
- craft wire
- white gesso
- archival varnish spray in gloss (Golden)

INSTRUCTIONS:

1. Gather rocks either from your garden or a local nursery or home improvement store. Make sure they are clean and dry. With a foam brush, apply a layer of white gesso to the tops of the rocks (figure 1).

2. Decide on the words that you'd like to place on the rocks and cut letters from vintage book pages to compose those words onto the rocks (figure 2).

3. With a small paintbrush, adhere the cut letters onto the gessoed rocks with Mod Podge, or other adhesive medium of your choice (figure 3).

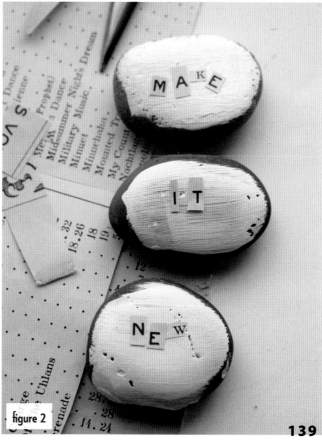

figure 2

139

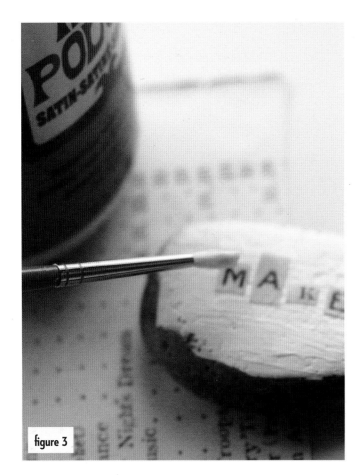

figure 3

figure 4

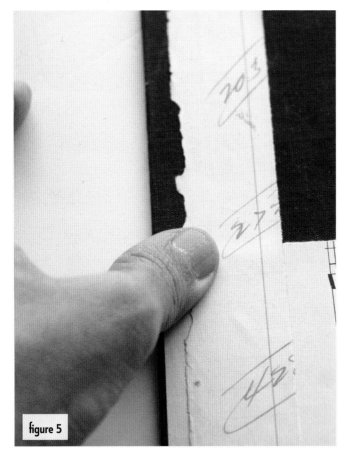

figure 5

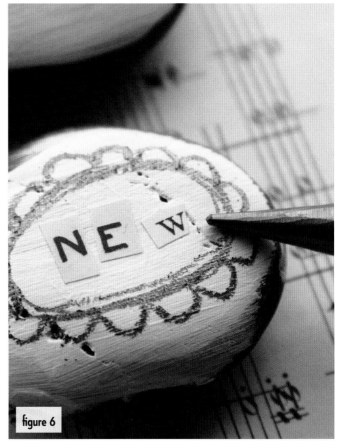

figure 6

figure 7

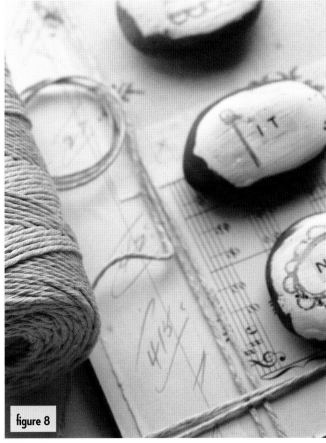
figure 8

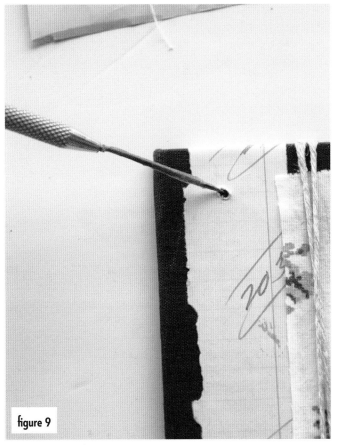
figure 9

4. Cut the cover from an old hardcover book. Gather vintage ephemera and fabric scraps to adhere to the book cover to create an attractive background to house the collaged rocks (figure 4).

5. Be sure to burnish all collage elements firmly with your fingers so that all air bubbles and wrinkles are smoothed out (figure 5).

6. Use a graphite pencil to add pencil work on the rocks in a pleasing manner (figure 6).

7. Use a strong-hold adhesive like E-6000 to adhere the rocks onto the collaged book cover (figure 7).

8. Gather hemp yarn or other fiber and add to the side and bottom portions of the book cover (figure 8).

9. With an awl or other sharp object, poke holes at the top corners of the book cover (figure 9). Cut a length of black craft wire and attach to the book cover by securing through the holes at the top of the book cover.

About the Contributors

SUZI BLU is a California-based artist known for her quirky and down-to-earth style. She teaches classes for students around the world through her online art school, Les Petit Academy. Follow the adventures of Suzi at *www.suziblu.typepad.com*.

JETTE CLOVER is a journalist, art historian, curator, and artist who lives and works in Antwerp, Belgium. Her work has been featured in numerous publications, including her most recent release, titled *Small Notes*. Learn more about Jette at *www.jetteclover.com*.

SUSANNAH CONWAY is an avid blogger, photographer, and writer living in the United Kingdom. To learn more about Susannah, her Unravelled workshop series, visit *www.susannahconway.com*.

ROBERT DANCIK has been an artist and teacher for more than 30 years and resides in Connecticut. To learn more about Robert, his workshops, or his book, *Amulets and Talismans: Techniques for Making Meaningful Jewelry*, visit *www.fauxbone.wordpress.com*.

MICHAEL DEMENG is a Missouri-based assemblage artist and author of *Dusty Diablos* and *Secrets of Rusty Things*. To learn more about Michael, visit *www.michaeldemeng.blogspot.com*.

JENNY DOH is President and Founder of multimedia arts community CRESCENDO*h*, LLC, and former Editor-in-Chief of mixed-media magazine *Somerset Studio*. Visit *www.crescendoh.com*.

DREW EMBORSKY, aka The Crochet Dude, blogs and creates from his studio in Houston, TX with his cats Chandler and Cleocatra. Learn more about Drew, his licensed crochet products, his crochet books, and his busy workshop schedule at *www.thecrochetdude.com*.

LISA ENGLEBRECHT is a graffiti-loving lettering artist living in southern California. To learn more about Lisa and her book, *Modern Calligraphy and Hand Lettering: A Mark-Making Workbook for Crafters, Cardmakers, and Journal Artists*, visit *www.lisaletters.blogspot.com*.

MARIE FRENCH lives and creates in west Texas, and is the author of *Inspiritu Jewelry: Earrings, Bracelets, and Necklaces for the Mind, Body, and Soul*. Learn more about her at *www.mariefrench.wordpress.com*.

SUSANNA GORDON is a Canadian-born artist, photographer, and enthusiastic blogger living with her American husband in New Jersey. To learn more about Susanna or her captivating winged messengers, visit *www.susannassketchbook.typepad.com*.

SARAH HODSDON is a mixed-media artist, designer, and instructor living in Michigan whose work can be seen in numerous publications. Learn more about Sarah at *www.sarah-n-dipitous.typepad.com*.

STEPHANIE LEE is a wife, mother, artist, and writer who repurposes intriguing bits and pieces into one-of-a-kind jewelry, and encourages others to do so in her debut book, titled *Semiprecious Salvage*. Keep up with Stephanie at *www.stephanielee.typepad.com*.

LK LUDWIG is a photographer, artist, and mother living in west Pennsylvania. She has authored four books, including *True Vision: Authentic Art Journaling*. Visit *www.gryphonsfeather.typepad.com*.

KAREN MICHEL is a mixed-media artist and author who creates work from recycled and repurposed materials, mojo, and sunshine. Follow the many facets of Karen's life at *www.karenmichel.com*.

CHRISTINE MASON MILLER is a Los Angeles-based artist and author who has been inspiring people of all ages for more than 15 years. Learn more about her or her celebrated book, *Ordinary Sparkling Moments*, at *www.christinemasonmiller.com*.

KELLY RAE ROBERTS is an artist, author, "possibilitarian," and all-around lover of life living in Oregon whose whimsical messages of positivity have been featured in numerous publications and in her heralded debut book, *Taking Flight*. Visit *www.kellyraeroberts.com*.

MELODY ROSS is a small town girl, wife, and mother of five from Idaho whose big dreams led her to launch Brave Girl Camp in 2009. To learn more, visit *www.bravegirlsclub.com*.

REBECCA SOWER is an internationally-recognized artist based in Tennessee whose artwork has been published in numerous publications. Learn more at *www.rebeccasower.typepad.com*.

SUSAN TUTTLE is a mixed-media artist and photographer residing in Maine who has authored two books, *Digital Expressions* and *Exhibition 36*. Learn more about her at *www.ilkasattic.blogspot.com*.

LYNN WHIPPLE is a mixed-media artist who creates quirky and unconventional artwork, including her popular Ninnies, at McRae Art Studios in Winter Park, Florida. Visit *www.lynnwhipple.com*.

Index

Feed the fires of your creative soul with these other North Light titles.

CREATIVE AWAKENINGS
Envisioning the Life of Your Dreams Through Art

Sheri Gaynor

Creative Awakenings is the key to opening the doors to your hopes and dreams, showing you how to use art making to set your intentions. Creativity coach Sheri Gaynor will be your guide through the mileposts of this exciting journey. You'll learn a variety of mixed-media techniques and a tear-out Transformation Deck will aid you in setting your intentions. You'll also get inspiration from twelve artists who share their own experiences and artwork created with the Art of Intention process.

paperback, 144 pages

CREATIVE TIME AND SPACE
Making Room For Making Art

Ricë Freeman-Zachery

With a fresh approach and an A-list group of contributing artists, *Creative Time and Space* embraces the idea that making time and space is at the core of creativity. It is not just about managing your time or setting up a studio space, it is about your mindset and about making room in your life for your craft. Enjoy active sidebars alongside photos of the work and workspaces of the featured artists, as they speak with refreshing candor about how they carve out creative time and space in their own lives.

paperback, 144 pages

INNER EXCAVATION
Explore Your Self Through Photography, Poetry and Mixed Media

Liz Lamoreux

There are clues all around you—sounds, textures, memories, passions—just waiting for you to shine a light on them, and unearth the most intimate form of expression—the self-portrait. Inside *Inner Excavation*, author Liz Lamoreux will be your guide, along with eleven inspiring artists, as you discover more about who you are, how you got here and where you wish to go. Prompts and exercises will show you how to express who you are through the photos you take, the words you write and the art you create.

Paperback, 144 pages

www.CreateMixedMedia.com
The online community for mixed-media artists

Techniques - projects - e-books - artist profiles - book reviews
For inspiration delivered to your inbox and artists' giveaways, sign up for our FREE e-mail newsletter.
These and other fine North Light Books titles are available from your local craft retailer, bookstore, online supplier,
or visit our website at **www.mycraftivityshop.com**